How to Paint
FLOWERS

WATSON-GUPTILL
Artists
LIBRARY

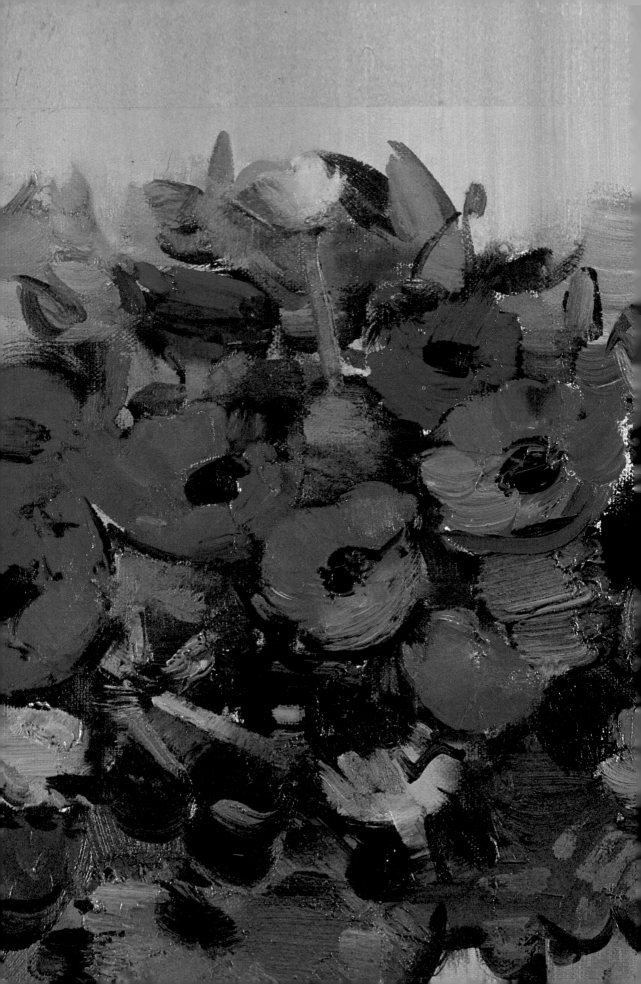

How to Paint
FLOWERS

José M. Parramón and Francesc Crespo

Watson Guptill Publications/New York

Copyright © 1989 by Parramón Ediciones, S.A.

First published in 1990 in the United States by Watson-Guptill Publications, a division of Billboard Publications, Inc., 1515 Broadway, New York, New York 10036.

Library of Congress Cataloging-in-Publication Data

Parramón, José María.
 (Arte de pintar flores. English)
 How to paint flowers / José M. Parramón and Francesc Crespo.
 p. cm.—(Watson-Guptill artist's library)
 Translation of: El arte de pintar flores.
 ISBN: 0-8230-2459-8
 1. Flowers in art. 2. Painting—Technique. I. Crespo, Francesc.
 II. Series.
 ND1400. P3713 1990
 751.4—dc20 89-48709
 CIP

Distributed in the United Kingdom by Phaidon Press Ltd., Musterlin House, Jordan Hill Road, Oxford OX2 8DP.

Manufactured in Spain
Legal Deposit: B-45.237-89

1 2 3 4 5 6 7 8 9 10 / 94 93 92 91 90

Contents

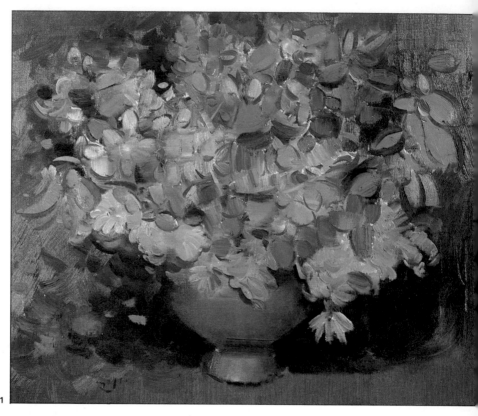

Figs. 1 to 3. Floral paintings by Francesc Crespo (top right; bottom left) and José M. Parramón (bottom right), the authors of this book.

1

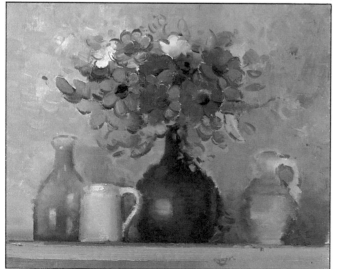

2

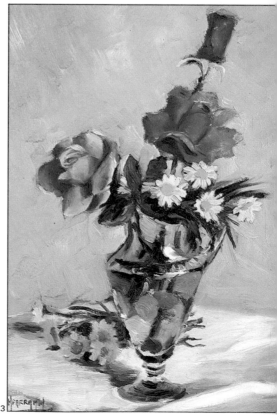

3

The joy of painting

"You ask me why I buy rice and flowers? You see, I buy rice to live on and flowers to have something to live for."

CONFUCIUS

It is a universally accepted fact that painting produces great spiritual satisfaction and even a feeling of well-being that is difficult to explain verbally. But of all varieties of genre painting, there is one kind that, more than any other, produces a sensation of great optimism and joy to the person who creates it: floral painting.

The vast variety and rich, bright colors of flowers transmit sensations of intrinsic beauty to those viewing them. For the artist or painter, this colorful manifestation generates spontaneous desire to capture and interpret such natural beauty on canvas. It is this feeling of exaltation that has produced great paintings in all different styles. Doesn't van Gogh's painting *The Sunflowers* automatically come to mind? A simple bouquet of flowers has not only bright colors but also a great complexity of forms from which an artist can get inspiration. The extraordinary perfection that many flowers possess has been translated into many important artworks.

The following pages will try to inspire those of you who feel the need to express yourselves through the forms and colors of flowers.

The book begins with a brief history that classifies this genre into the general context of the history of painting. Then you will study the conceptual and technical aspects of painting flowers. The materials and techniques most widely used for this genre are presented and described completely and precisely. The principal protagonist, color, is analyzed from a very specific point of view, avoiding any unnecessary complications.

All the creative possibilities flowers offer are considered, from painting outdoors to working on a composition in the studio, from painting a simple vase of flowers to painting a myriad of flowers in a variety of landscapes. And naturally, the importance of drawing in the process of painting flowers is not overlooked. A complete chapter explains the most important aspects of drawing.

Finally, the wide range of illustrations included show you that all styles of painting can be used for this subject.

In the Orient, especially in China and Japan, flowers have been used as a pictorial theme for centuries. In the West, flowers—similar to other still life subject matter—were used as decorative elements in frescoes and mosaics. At the end of the 16th century, the first true still lifes were painted by artists of the Dutch school and the Italian painter Caravaggio. In France during the 18th century, the painting of still lifes, especially flowers, became a common theme among the artists of that time. Later, the impressionists and then the modernists, from Monet and van Gogh to Oskar Kokoschka, gave form to their ideas about light, composition, and color through painting still lifes.

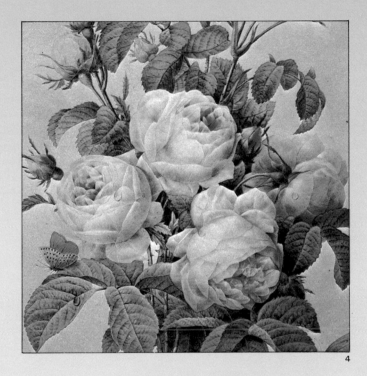

4

HISTORY
OF THE GENRE

Decoration in the West, art in the East

Curiously, painting flowers as a main theme for aesthetic rather than simply decorative purposes appears quite late in the history of Western art. The Greeks and Romans decorated their houses with frescoes and mosaics on floral themes, but it was done in the same way that we hang wallpaper today. During the Middle Ages many illuminated manuscripts contain pages decorated with flowered garlands. In the many books about plants that were published throughout the centuries, drawings and engravings served only for descriptive purposes.

In the East it was an entirely different matter. For hundreds of years in China, the floral theme had been cultivated by many important artists, who developed floral styles of incredible beauty. During the long epoch of the Sung dynasty (960-1279), the painting of flowers and birds reached such high standards that you could possibly con-

sider them unsurpassable. Another e[x]ample is that of Japan, where trad[i]tional folding screens were decorat[ed] with such themes as plants, bambo[o] and flowers. This developed into an e[x]tremely refined art form, using ve[ry] unique techniques.

It is interesting to note that both [in] China and Japan, the painting tec[h]niques employed were almost excl[u]sively ink and watercolor. Because [of] the fluid and direct approach used [to] interpret natural forms in Eastern ar[t] the brush was the ideal tool. The pain[t]ings were done on paper or silk th[at] was rolled up once the works we[re] completed.

Fig. 4 (preceding page). Pierre-Joseph Redouté (1759-1840), *Bunch of Flowers with Butterflies* (detail), private collection, London.

5

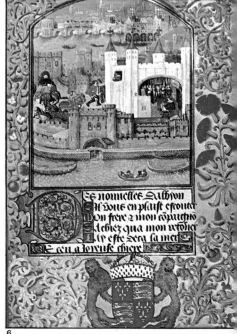

6

Figs. 5 and 6. *Livia House in the Palatino, Rome,* and a page from a manuscript on the poems of Carlos de Orleans, imprisoned [in] the Tower of Londo[n] Parchment of the ye[ar] 1599. British Museu[m] London.

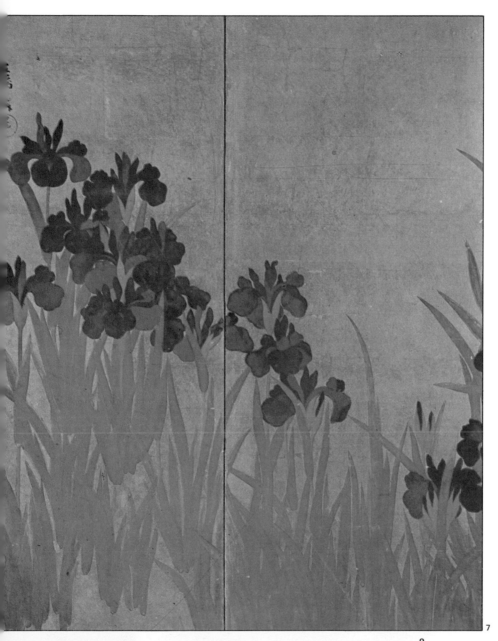

7

9

Figs. 7 to 9. Ogatu Khörin (1658-1716), Japanese art of the Edo period, *Iris*, Nezu Museum, Tokyo. Te Ch'ien, *Lotus Flowers and Aquatic Birds*, National Museum, Tokyo. Wu Chen, *Bamboo*, National Palace of the Central Museum of the Republic of China.

From botanical studies to floral paintings

The Dutch school of painters that emerged toward the end of the 16th century were universally recognized as the founders of the floral painting genre. Many Dutch and Flemish artists developed the floral theme as subject matter for their paintings for more than two centuries, thus contributing to its acceptance as an art form.

Perhaps it is necessary for us to refer to Albrecht Dürer (1471-1528) as the true founder of the genre. His studies on the floral theme were unusual for that time, especially his watercolors, which influenced so many painters of the Dutch school.

In Europe, floral paintings were created as botanical illustrations for a long period of the time. Herbals—books on

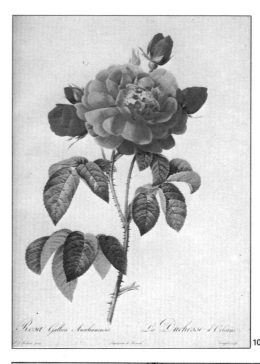

Fig. 10. Pierre-Jose Redouté (1759-184 *The Roses,* paint around 1825, priva collection, London.

Fig. 12. Albrecht Dür (1471-1528), *The E Clod (Grass),* Albertir Vienna.

Fig. 11. Roelandt Savery (1576-1639), *Flowers in a Niche with Reptiles and Insects,* Central Museum, Utrecht.

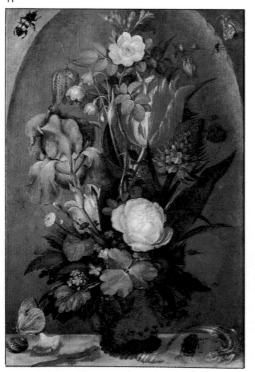

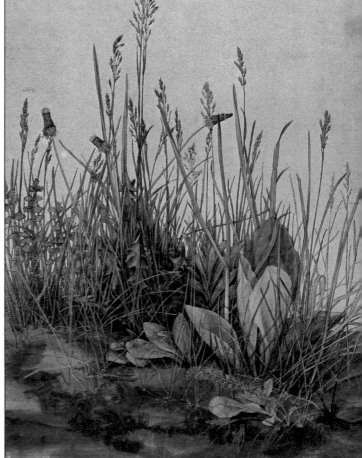

:dicinal plants and flowers—
ntained many pictures, most of
nich were copied from a five-volume
ork compiled by the Greek medical
pert Dioscorides in the first century
.D. For the most part, the flower
intings and drawings of that time
ere poor in quality and left much to
 desired; they lacked the aesthetic
servation of the natural subject mat-
r, an essential source for any kind of
tistic interpretation.

But in the 14th and 15th centuries, in
Italy and Germany, some herbal books
appeared that were notable for the
realism and naturalness in their plant
and flower illustrations. From that
point on, botanical artists became
more expressive and used better tech-
niques, thanks to rapid advances in the
natural sciences. Floral art was en-
hanced even more by expeditions to the
New World, which yielded new and ex-
otic plants.

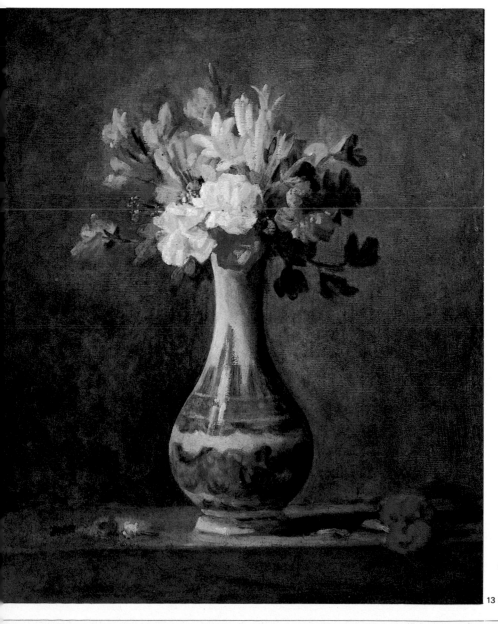

Fig. 13. Jean-Baptiste
Siméon Chardin (1699-
1779), *Flowers in a Blue
Vase*, National Gallery of
13 Scotland, Edinburgh.

Flowers in impressionism

Impressionism, which occurred during the later part of the 19th century, opened the door to modern art. From that moment on, painters would incorporate flowers as a theme in the general context of their works.

The exaltation of light and color, as well as the quality of the subject matter, became a constant in the different styles that followed impressionism. There was no doubt that the organic forms and bright colors of flowers represented excellent subject matter, perhaps better than any other natural or artificial forms.

fact, this period of innovation during impressionism has been qualified by many artists and critics as being the true beginning of what is known as abstract painting.

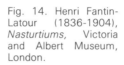

Fig. 14. Henri Fantin-Latour (1836-1904), *Nasturtiums,* Victoria and Albert Museum, London.

Fig. 15. Pierre-Auguste Renoir (1841-1919), *Spring Flowers,* Fogg Art Museum, Cambridge, Massachusetts.

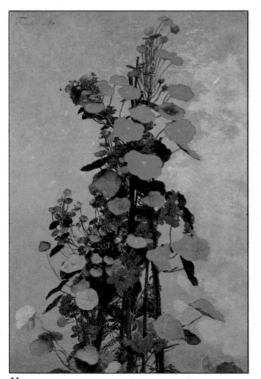

14

15

Artists such as Henri Fantin-Latour, Claude Monet, Pierre-Auguste Renoir, Vincent van Gogh, Paul Gauguin, Henri Matisse, and Piet Mondrian, to name just a few, painted pictures on the floral theme that are considered by many to be among their best work. Claude Monet (1840-1926) painted a series of works, the famous *Water Lilies,* or *Nymphéas,* in which his bold use of light and color produced a unique interpretation of the subject. In

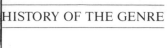

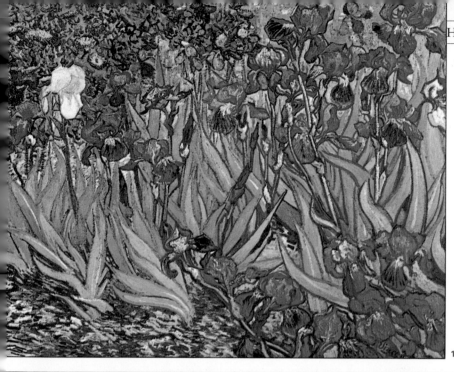

Fig. 16. Vincent van Gogh (1853-1890), *Irises,* private collection.

Fig. 17. Claude Monet (1840-1926), *Lake with Water Lilies,* Quai d'Orsay Museum, Paris.

16

17

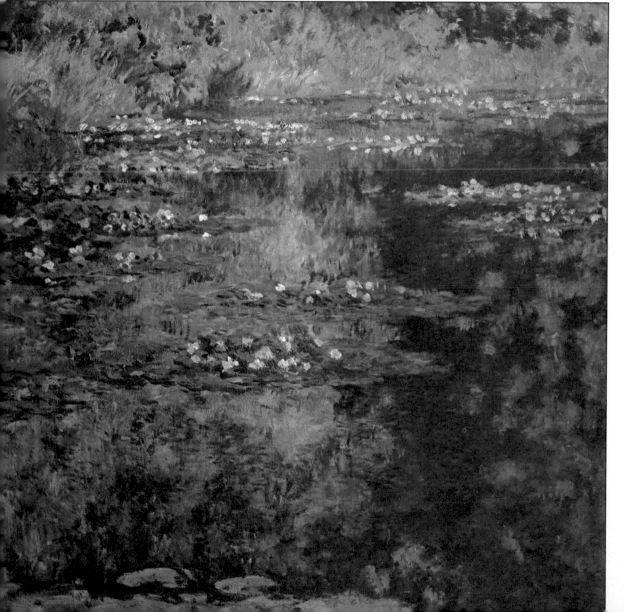

Floral painting today

There is no doubt that the impressionists, with Monet as the prime innovator, influenced many of the styles of the paintings of today. The movements that followed impressionism, in chronological order, were: **postimpressionism** (1890), **fauvism** (1905), **cubism** (1908), **expressionism** (1918), **surrealism** (1919), and, as a consequence of this constant restlessness, **abstract art** (1910).

With the exception of abstract art, the floral theme has remained a constant within many of the art movements. Van Gogh's postimpressionist floral paintings are a good example of the importance of flower painting in the history of art, as evidenced by the enormous, unprecedented sum his *Irises* brought at auction. Emil Nolde, another postimpressionist and a follower of van Gogh, Edvard Munch, and James Ensor, adopted the floral theme in most of his work. One of the major artists of fauvism, Matisse, painted flowers in many of his pictures, either as the main subject or as a decorative element in portraits or interiors. The expressionist painter Kokoschka and the surrealist René Magritte also painted flowers. As you have seen, floral painting is a classical and common subject of the art of today and has been used by many painters all around the world.

18

19

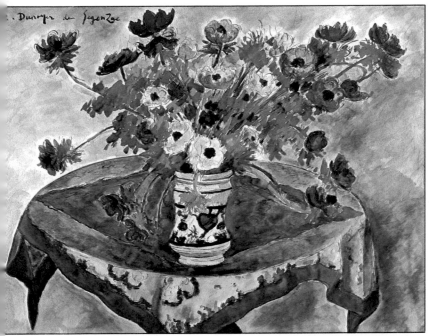

Fig. 18. Oskar Kokoschka (1886-1980), *Flowers,* private collection.

Fig. 19. Maria Rius, illustration for a children's book, *Smell,* private collection.

Fig. 20. André Dunoyer de Segonzac (1884-1974), *Anemones and Blue Veladores,* private collection.

Fig. 21. Emil Nolde (1867-1956), *Big Poppies,* private collection, London.

20

21

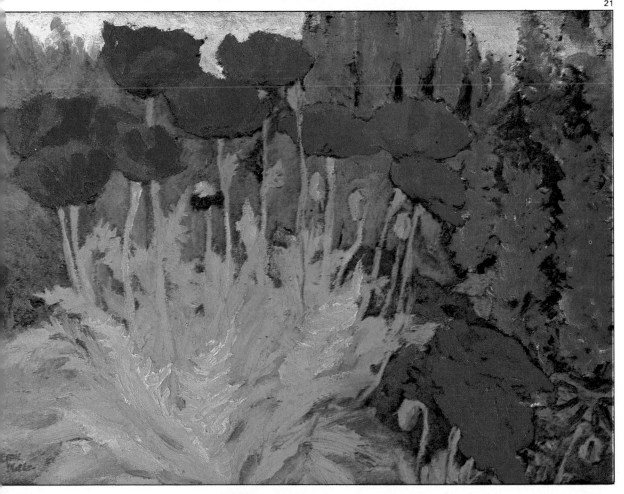

In this chapter, we will tell you
about the painting materials you will
need for flower painting in the three
classic mediums: oil, watercolor, and
pastel. You will also find
information about other mediums,
such as colored pencils, wax crayons,
oil pastels, and acrylic colors.
Whatever technique you use, you
must know the material well. Read
the text carefully and take note of
the illustrations that describe the
most suitable materials for each
technique, the color presentation, the
brushes, and the different quality
pastels, crayons, and pencils. After
selecting the appropriate materials,
we will be ready to paint flowers.

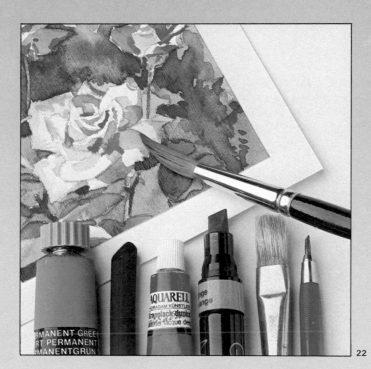
22

MATERIALS
AND
PROCEDURES

The basic palette

It should be noted that the materials and methods used in painting flowers are the same as in any other subject. There are no differences in this respect. Of course, each technique has its particularities, which we will discuss. Nevertheless, the most "classic" mediums, the ones that are most frequently used for this subject matter, continue to be oil, watercolor, and pastel. But it is good to experiment with other mediums. We can even use various mediums in the same composition. The choice depends on the personality of each artist as well as the needs and experience he or she has.

Apart from that, whatever medium the artist chooses to use, we recommend that he or she use a *basic palette.* Naturally, the basic palette depends on the preferences of each individual, but as you know, there are three basic colors, red, yellow, and blue, which are known as the *primary colors.*

Here is an example of a *basic palette:*
Cadmium lemon yellow
Yellow ochre
Cadmium yellow-orange
Cadmium red light
Carmine madder deep
Burnt umber
Viridian
Cobalt blue light
Prussian blue
Titanium white
Ivory black

23

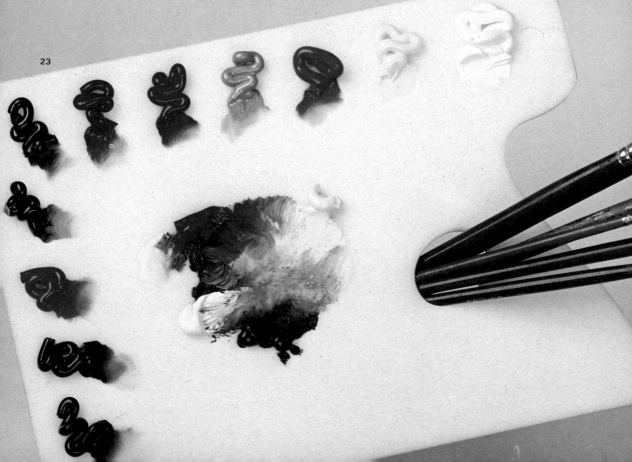

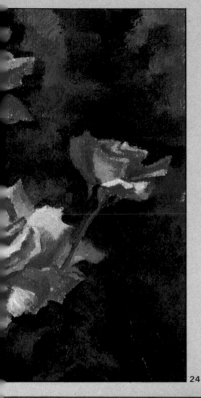

24

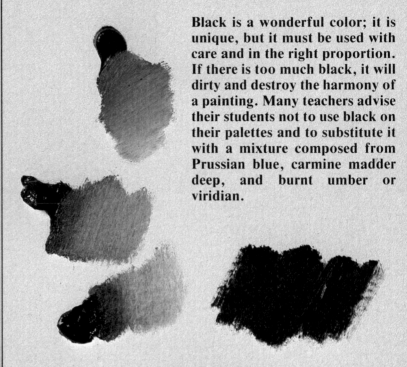

Black is a wonderful color; it is unique, but it must be used with care and in the right proportion. If there is too much black, it will dirty and destroy the harmony of a painting. Many teachers advise their students not to use black on their palettes and to substitute it with a mixture composed from Prussian blue, carmine madder deep, and burnt umber or viridian.

25

26

Fig. 23. Here you can see the colors of a basic palette. In the center is a mixture of yellow, carmine madder deep, and Prussian blue. These colors are considered *primary colors* with which it is possible to compose all the colors of nature.

Fig. 24 (top, left). This picture of three roses was painted in oil with only three colors and white: cadmium yellow medium, madder deep, Prussian blue, and titanium white. It is a good example of the capacity of the three *primary colors* to achieve all the shades and colors of nature.

Fig. 26. Painting by Francesc Crespo, using the colors of the basic palette in figure 23.

"Specific" colors for painting flowers

Some flowers have colors that are particular to themselves, and are sometimes so saturated—especially in the red scale—that it would be difficult to obtain the exact color by using the colors of the basic palette. You could also run the risk of dirtying them and that would be unforgivable when painting flowers.

Many paint manufacturers produce many different tones of red and violet, which are made with great intensity and brightness, and correspond to the unique colors of flowers. Every paint manufacturer has their own particular name for the colors; sometimes they coincide and sometimes they do not. In reality they are the same colors, but may have a slight difference in tone. We have chosen four specific colors for you to look at: *red purple, cobalt violet light, madder lake pink,* and *permanent violet.*

So, depending on the type of flowers you want to interpret, you can use one or two of these special colors to obtain bright and intense colors, or even subtle delicate shades. These special colors will help you achieve specific transparencies without tedious mixing. You only have to lighten them with white when it is required.

Fig. 27. Nowadays, many of the best colors are artificial. Modern chemistry has created bright pigments that are solid and stable to light. In the case of reds and violets, *alizarin,* **a substance once derived from the plant called** *Rubia tinctoria,* **is now made synthetically. Cobalt violet is another extraordinary color; it has been used since the middle of the 19th century. The color is made from cobalt phosphate and comes light or dark.**

28

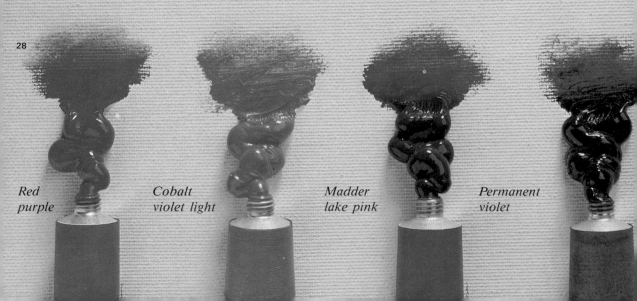

Red purple *Cobalt violet light* *Madder lake pink* *Permanent violet*

Fig. 29. From this floral painting, *Anemones*, by Crespo, you can see the results of mixing the four "special" colors shown at the bottom of page 22.

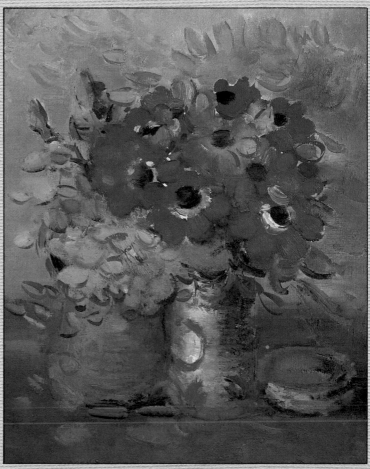

29

Fig. 30. Crespo employs not only industrially manufactured colors, but he also uses his own mixtures. This palette shows the colors that Crespo uses often: yellow ochre, neutral gray cool, sienna gray warm; and blus-gray.

30

Oil colors

Oil colors, along with pastels, have been a traditional means of painting floral themes. They are made up of powdered pigments with oil fat (sunflower seed, nut, or poppy oil), wax, and resin additions.

As you may already know, commercial oil colors come in tin tubes of four or five sizes; white comes in the largest size since more quantity is needed in this color. There are many colors available. Some color charts include up to ninety different colors, though most painters almost never use more than ten or twelve colors in one painting. For oil painting, you need to use a bristle brush, which is hard and at the same time flexible. Sable- and mongoose-hair brushes are soft and are used for delicate strokes—colors that are dilut-

ed or thinned. By the way, to contro the thickness and drying time of o paints, there are various oils and va nishes you can use as thinners. The are special products marketed for thir ning paint colors, but the basic formu la is composed of linseed oil mixe with turpentine. This dissolvent mi ture must contain a higher amount c turpentine than linseed oil in the fir coats, in order to prevent the pair from cracking.

A final piece of advice: when you ar ready to start your oil painting, be sur to have plenty of rags and ol newspapers handy—better still, a ro of absorbent paper—along with a spa ula to periodically clean your brushe and palette.

Figs. 31 and 32. Generally speaking, oil painting is the most popular medium, and perhaps it is the best for painting flowers.

31

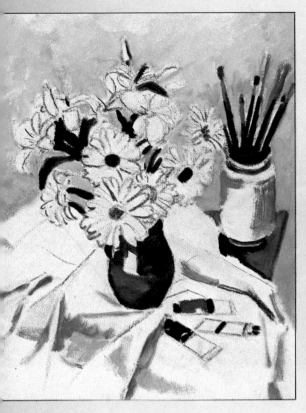

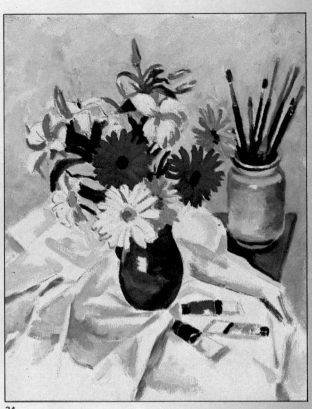

34

gs. 33 to 35. In the step-by-
ep development of this paint-
g, you can see how the
aqueness of the oil colors

worked well. The subject mat-
ter needed layers of superim-
posed colors to show the mul-
tiple shades of this still life.

35

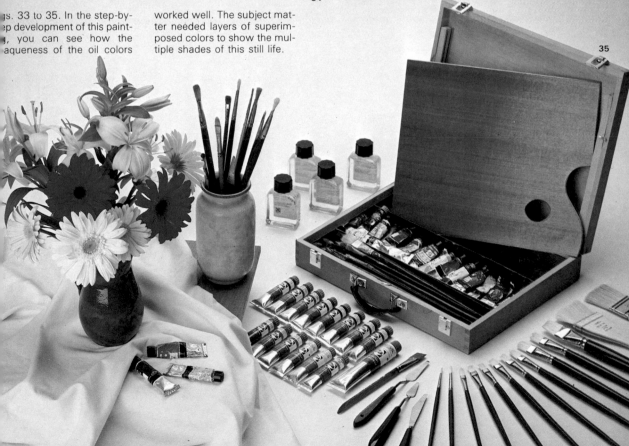

Watercolors

Watercolors are made up of pigment bound with gum arabic, glycerine, honey, and water. There is a great variety of watercolor products on the market: pans of dry watercolors, pans of wet watercolors, tubes of creamy watercolors, and jars of liquid watercolors. The most widely used are the dry and creamy watercolors.

The best brush to use is the sable-hair brush: the hair has a great capacity for bending under the pressure of the artist's hand, and then reverting to its original form, never losing its perfect point.

Today most paper manufacturers distribute paper in blocks of twenty-five sheets. Each sheet sticks together at the four corners, so you can paint directly on the block without warping the paper or allowing moisture to form in the pockets of the paper. If you decide to paint on a lighter weight paper, up through 140 lb., you should follow the traditional procedure of first wetting and stretching the paper and then adhering it, along the edges with drafting tape, onto a wooden board.

As you may already know, in watercolors—real watercolors—you use the white of the paper as the color white. For this reason, you save the white for last. For example, when white daisies on a dark background are small, they can be painted in with *liquid gum,* a product that is applied with a synthetic brush. The gum forms a waterproof film, which allows you to paint over or around the forms you have saved. Once the watercolor is dry, the liquid gum can be removed by using an eraser or your fingers, thus leaving the saved white areas ready to be painted.

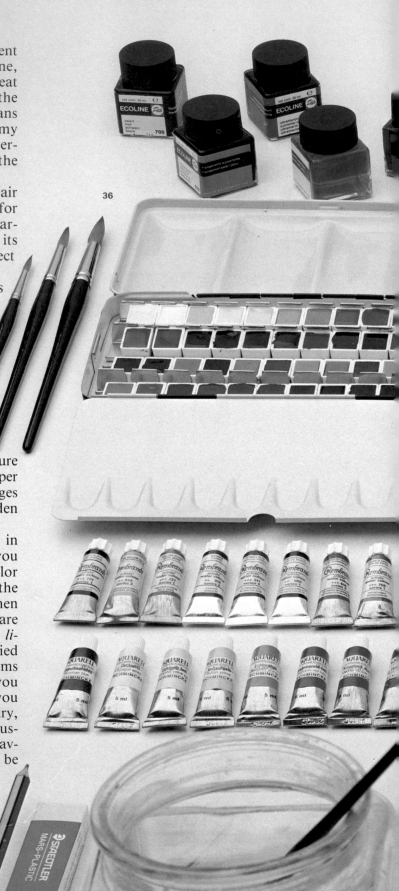

36

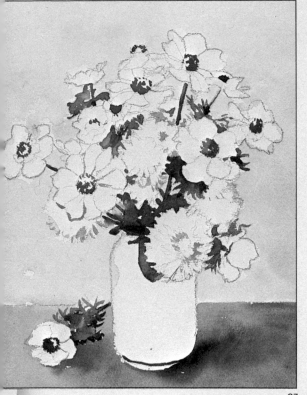

37

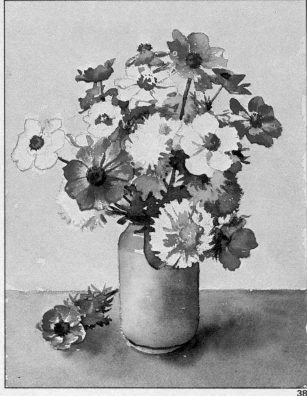

38

Figs. 36 to 40. Watercolors are an ideal medium for painting flowers, mainly because of the luminosity and tranparency that are created by the white of the paper.

39

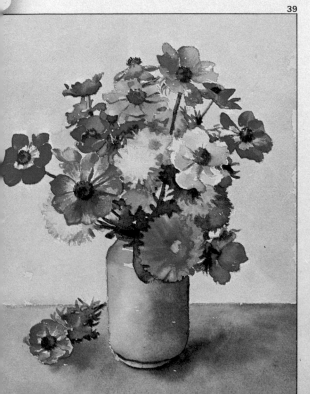

40

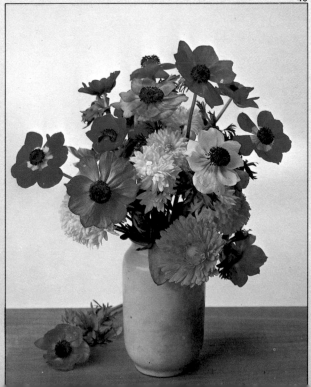

Pastel colors

Now we are going to talk about the materials needed to paint with pastels, another classic medium for painting floral themes.

Pastels are composed of powdered pigment bound with gum arabic. For the best results when painting with pastels, you should paint light over dark. But the most favorable characteristic of pastel is the ease with which you can mix several colors in the same area, simply by stumping the colors with your fingers.

Pastels come in a wide range of colors, which almost covers the entire spectrum. For easy manipulation, pastels are manufactured in rod and pencil forms.

Usually, medium- or thick-grain colored paper, such as Canson Demi-teintes or Ingres, is used for pastel painting. The paper should be attached to a wooden board or any other rigid surface. Among the accessories needed for painting with pastels are two kinds of erasers: a plastic one for cleaning or eliminating a form, and a malleable one—which can be molded with your fingers to produce a fine clean point that you can use to draw a stroke or add a highlight. Two or three paper stumps are needed—thin, medium, and thick—to stump the areas where you cannot use your fingers. Also, you should have a radial, fan-shaped bristle brush for mixing colors, and a cloth and a roll of absorbent paper to rub out wide surfaces and to resolve stumping.

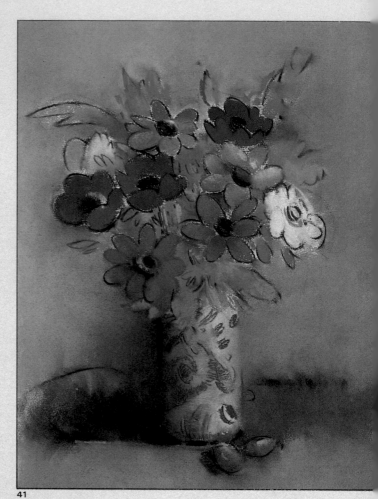

41

Figs. 41 and 42. Flowers are a common theme that many artists, working in all mediums, have painted at one time or another. Pastel colors are well suited for floral pictures.

42

Colored pencils

olored pencils are manufactured the me way as graphite ones. The only fference is that the colored pencil d is composed of colored pigments, und with a mixture of wax and kaol-. The line drawn from a colored pen- is rather soft. Unlike graphite pens, colored pencils are not made in fferent degrees of hardness, though me manufacturers do produce lored pencils of a softer degree.

any colored pencils on the market e called *water-resistant* or *watercolor* d can be used along with other techques, such as painting over colored ncil strokes with water-moistened ushes. The finished product is simi- r to what you would obtain with atercolor, although with the use of ater-resistant pencils, you get a more tailed finish since the pencil lines re- ain visible.

ou can use either white or colored per when working with colored pens. The fine- or medium-grain Canson Demi-teintes paper is well suited for this medium. Of course, it is also possible to use rough grain or glossy paper, but they are usually used to create a special texture or finish.

When painting with colored pencils, you need a wooden board to rest the paper on, and some pins to hold the paper down; you must also have two or three sable-hair brushes, a water container, a sponge, and a roll of absorbent paper. Probably the most essential items you will need are sandpaper and a cutter—an X-Acto knife or pencil sharpener—for sharpening your colored pencils.

The colored pencil picture on this page shows you the "pictorial" possibilities of this medium. As you can see, colored pencils are ideal for practice and experimentation with color mixing.

Figs. 43 and 44. Colored pencils are not a very common medium for painting in general. But as you will see and study in the following pages of this book, they can give good results.

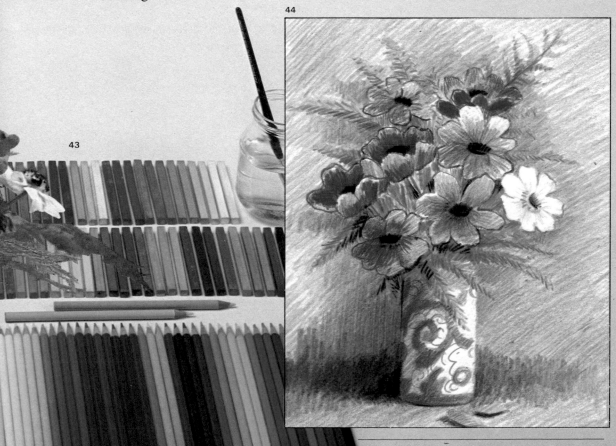

43

44

Acrylic colors

Acrylic colors were first sold in the United States during the 1950s. They are synthetic paints that combine oil and watercolor techniques. Similar to watercolor, acrylics dilute well in water, allowing thin and almost transparent coats; but they can also be used to paint in impasto (with thick coats of paint), in the same manner as oils. Acrylics dry relatively fast, and once dry they are insoluble to water. But you can control the color solubility as well as the drying time by adding a medium to the water. These mediums are placed into two main categories: *thickeners,* to obtain more opaque colors; and *retarders,* to delay the drying time of the color.

There is a wide selection of colors available; they come in jars and tubes of different sizes. With acrylic colors, you can paint on practically any surface. But if you paint on a wooden board, it is best to first paint it with a thick coat of a white background, usually gesso, which is sold by most paint manufacturers.

The brushes, palettes, and spatulas are used in the same way as you would use them with oils. However, when painting with acrylics, clean your tools carefully with soapy water; if by accident you let the paint dry on the brush or palette, soak them in acetone.

Figs. 45 and 46. With acrylic colors you can paint perfect chromatic pictures; this is due to the opaqueness of acrylic colors, which can be diluted in water. The above painting, by Miquel Ferrón, is a good example.

45

46

Wax crayon and oil pastel colors

Now we are going to look at two very different materials, although they are similar in regard to their possibilities and techniques: wax crayons and oil pastels. Wax crayons are made by fusing together bound pigments with grease materials at a specific temperature. During the manufacturing of oil pastels, the powdered pigments are bound with oil and grease materials, as with oil paints.

The techniques used when painting with these colors vary, depending on the quality of the color, and whether it is hard or soft. The way you apply hard colored crayons is similar to the way you would use colored pencils, while the way you apply soft colored crayons is equivalent to pastels.

Both wax crayons and oil pastels are opaque—light colors can be painted over dark ones. However, in spite of the similarities to oil painting techniques, oil pastels, which have better ductility, are the most opaque.

To start painting with wax crayons or oil pastels, you need a brush, a jar of turpentine, and a cup. By dissolving colored shavings in a cup of turpentine, you can obtain liquid colored wax.

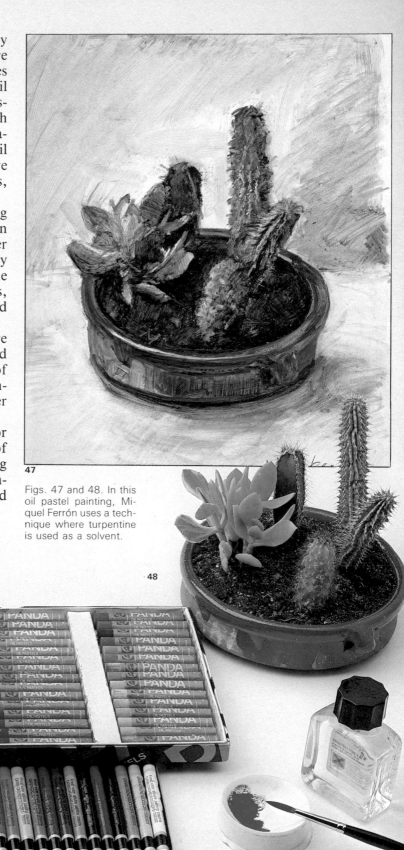

47

Figs. 47 and 48. In this oil pastel painting, Miquel Ferrón uses a technique where turpentine is used as a solvent.

48

31

Color charts

Manufacturers' color charts include a great variety of shades for each color. So whether you are painting with oils, watercolors, pastels, or acrylics, you can choose from a wide spectrum of shades, which in some charts can offer up to twenty-seven different types of yellow and twenty-five reds. Does that mean you will use them all? As you already know, it is possible to obtain all the colors of nature by mixing unequal proportions of the primary colors: blue, red, and yellow. However, it is highly impractical, as a rule, to mix the primary colors every time you need a specific shade or color when you can choose from a wide variety of tones and shades available in art stores.

Even so, most artists, but by no means all of them, paint with ten or a maximum of twelve colors, not including black and white.

How does the wide range of colors help the artist? It is simple; you will notice that each artist has a different sense of color. For example, not many artists will use the same blue or green in the same way. Every artist tends to employ different tones, which helps to build up his or her own personal color chart and spectrum.

In the color chart shown on this page, the crosses indicate the degree of permanence of each color. The manufacturer's warning about how permanent colors really are is to be taken into account, but one should not worry excessively about it. This reference is applicable to other mediums such as oil, acrylic, gouache, and so forth.

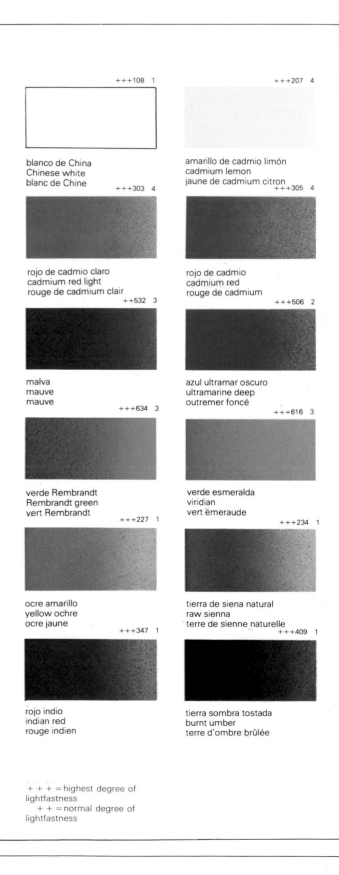

+++108　1
blanco de China
Chinese white
blanc de Chine

+++207　4
amarillo de cadmio limón
cadmium lemon
jaune de cadmium citron

+++303　4
rojo de cadmio claro
cadmium red light
rouge de cadmium clair

+++305　4
rojo de cadmio
cadmium red
rouge de cadmium

+++532　3
malva
mauve
mauve

+++506　2
azul ultramar oscuro
ultramarine deep
outremer foncé

+++634　3
verde Rembrandt
Rembrandt green
vert Rembrandt

+++616　3
verde esmeralda
viridian
vert émeraude

+++227　1
ocre amarillo
yellow ochre
ocre jaune

+++234　1
tierra de siena natural
raw sienna
terre de sienne naturelle

+++347　1
rojo indio
indian red
rouge indien

+++409　1
tierra sombra tostada
burnt umber
terre d'ombre brûlée

+ + + = highest degree of lightfastness
+ + = normal degree of lightfastness

Fig. 49. Here, we have reproduced a color chart as a general reference for the choice of colors available. From studying this chart, you will get a better idea of the shades of specific colors, such as red, carmine, greens, and blues.

49

This watercolor chart has been reproduced with special permission from the firm **Talens.**

+++208 4

amarillo de cadmio claro
cadmium yellow light
jaune de cadmium clair

++238 2

gomaguta
gamboge
gomme-gutte

+++210 4

amarillo de cadmio oscuro
cadmium yellow deep
jaune de cadmium foncé

+++211 4

anaranjado de cadmio
cadmium orange
orange de cadmium

+++306 4

rojo de cadmio oscuro
cadmium red deep
rouge de cadmium foncé

++318 2

carmín
carmine
carmin

+331 2

laca de garanza oscura
madder lake deep
laque de garance foncée

+++539 4

violeta de cobalto
cobalt violet
violet de cobalt

+++511 4

azul cobalto
cobalt blue
bleu de cobalt

+++534 4

azul cerúleo
cerulean blue
bleu céruléum

+++520 3

azul Rembrandt
Rembrandt blue
bleu Rembrandt

++508 1

azul de Prusia
Prussian blue
bleu de Prusse

+++645 3

verde Hooker oscuro
Hooker's green deep
vert de Hooker foncé

+++623 3

verde vejiga
sap green
vert de vessie

+++620 2

verde oliva
olive green
vert olive

+++629 2

tierra verde
terre-verte
terre verte

+++408 1

tierra sombra natural
raw umber
terre d'ombre naturelle

+++339 1

rojo inglés
light oxide red
rouge anglais

+++411 1

tierra de siena tostada
burnt sienna
terre de sienne brûlée

++333 2

laca de garanza alizarina
brownish madder (alizarin)
laque garance brunâtre (aliz.)

+++416 1

sepia
sepia
sépia

+++708 1

gris de Payne
Payne's grey
gris de Payne

+++533 1

índigo
indigo
indigo

+++701 1

negro marfil
ivory black
noir d'ivoire

The figures 1, 2, 3, and 4 indicate the price groups. Colors illustrated are made with the original pigments.

Many still lifes are composed with flowers, mainly because it is one of the pictorial themes that gives the artist most freedom in choosing the model. The artist can easily select and combine different types of flowers, arrange them according to their forms and colors, add various objects to the painting, and decide on the quality and direction of the light. When selecting subject matter, is important to know—and put into practice—tone and color contrasts.

This chapter will tell you where and how to paint flowers; it will explain how to illuminate your still life to bring out the flowers' life and color contrast in your painting.

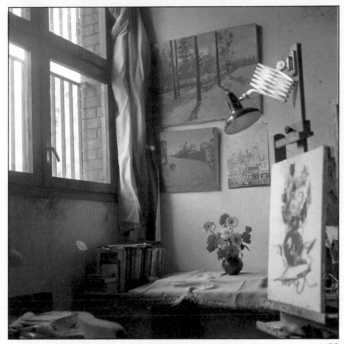

50

SUBJECT
AND
LIGHTING

Flowers everywhere

As subject matter, flowers can offer a painter unlimited possibilities. You can find flowers in many different environments, and sometimes all year round. A painter can choose from the most common flowers that are grown in flowerpots, gardens, and greenhouses, to flowers that grow wild in the contryside, along with different varieties of herbs. In short, the choice of flowers for subject matter is practically infinite.

It is always a good idea to visit a florist and nursery, now and again, to familiarize yourself with the different kinds of flowers, what time of the year they bloom, and when they are at their best. As a result, you wil make a better composition for your next project. On the next page you can see paintings by three contemporary artists, who are similar to one another only by the floral theme. These different flowers have inspired each of these artists to create paintings of very different and distinct expressive styles.

In these paintings you can also see that technique helps to determine the character of the work. That is to say, any theme or subject can be treated with several different painting methods, no matter what the painter's style is. For that reason, it is better to begin by freely practicing different techniques until you find your own style.

Figs. 51 to 54. It is easy to find flowers to paint: in the garden, in the country, in florist shops, and even inside your home. There are all kinds of flowers, from the wildflowers found in the country to the dry type that you see in figure 54.

52

51

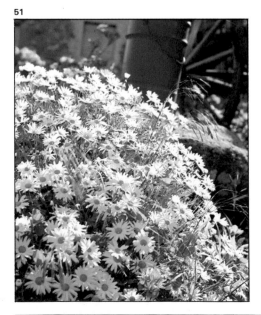

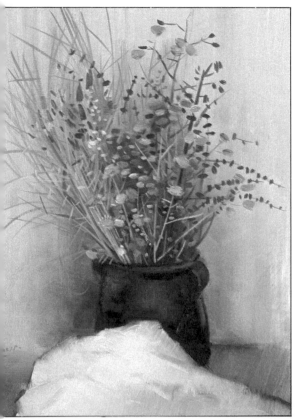

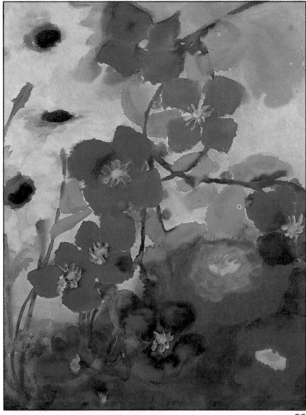

56

57

Fig. 55. Francesc Crespo, *Dry Flowers,* private collection.

Fig. 56. Emil Nolde (1867-1956), *Flowers,* private collection.

Fig. 57. Edward Burra (1905-1976), *Flowers,* private collection.

Painting flowers in their natural environment

One of the most attractive and interesting aspects of painting flowers is that you can venture out to the country, park, or garden to sketch or paint your subject matter. Many flowers are at their best in their natural environment, where it is not necessary to "arrange" them. Flowers in their natural setting are ready to be painted exactly as you find them, surrounded by other plants and bushes, making a perfect subject for a painting. You can make sketches and color notes with watercolors, wax crayons, pastels, or colored pencils that can later become paintings in the studio. But as we said before, you can always take your equipment out of the studio and paint outdoors. It is a purely personal matter where you decide to paint; the most important thing is the final result.

Also, don't forget that color photographs can be an enormous help in capturing details.

58

Fig. 58. In parks and public gardens you can easily find flowers and plants to paint outside.

Fig. 59. Pierre-Auguste Renoir (184 1919), *Monet Painting in His Garde* the Wadsworth Athenaeum. The I pressionists often painted flowers a plants outside, as you can see in t picture by Renoir, in which he portra his friend Monet painting in his garde

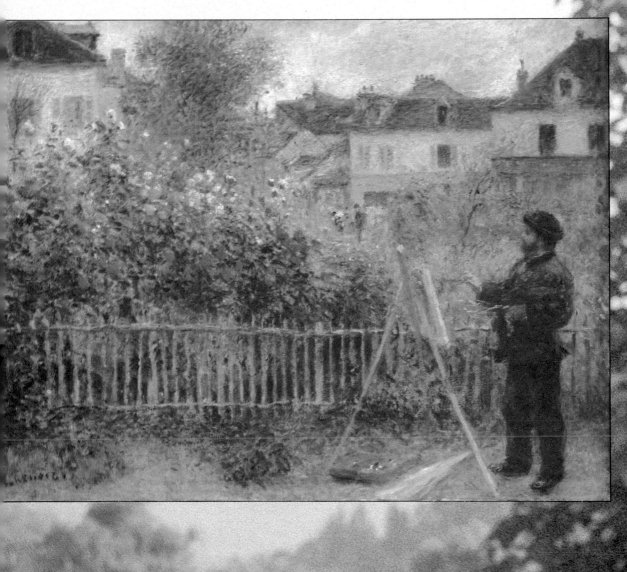

Painting flowers in the studio

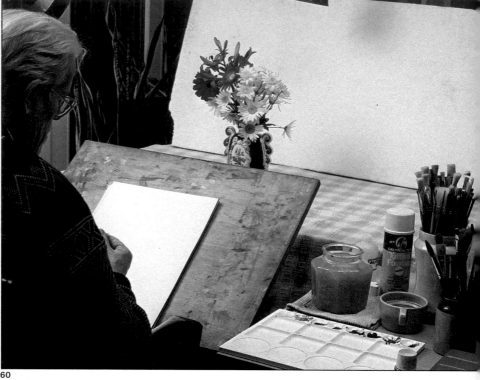

Fig. 60. The studio is generally considered the most practical place for painting flowers. In the studio the artist can study in depth the lighting, the color harmony, and the techniques he or she plans to use for the painting.

60

Just as the flowers in the countryside, garden, and nurseries have inspired artists, so have humble bunches of picked flowers. Flowers are easy to find, and, because of their size, very manageable; they can be kept in all kinds of jars and vases. The main advantage is that they can be painted almost anywhere, which greatly simplifies the preparation process. Generally speaking, artists prefer to work from flower arrangements which they cut and combine themselves.

Flowers have a rapid withering and fading factor, but you can solve this problem by opening up the ends of the flower stems so they can absorb more water, or you can dissolve an aspirin in the water, which seems to prolong the life of flowers. You could also use wire to suspend the flowers in the original position. It's also important to remember that flowers close at night and open in the morning. Flowers should be painted quickly, in a maximum of two sessions or two days, in order to capture their full life and color. In fact, constantly painting over the same areas will only produce withered flowers in your painting.

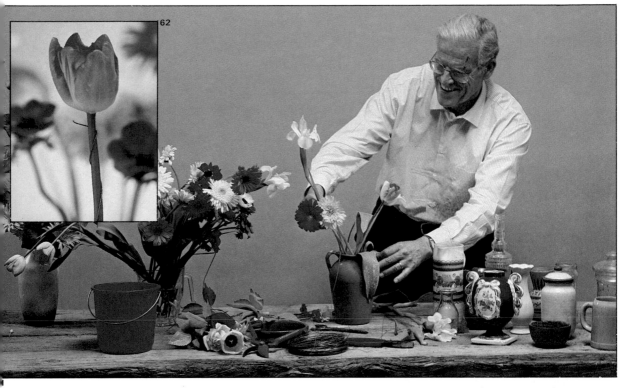

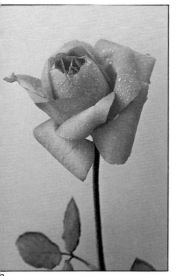

64

Figs. 61 to 65. Prior preparation is needed when you plan to paint flowers in the studio. The objects and material for the still life must be chosen and the flowers need to be arranged.

Sometimes you may need to use some thin wire to hold the stems in place, as you can see in figure 62.

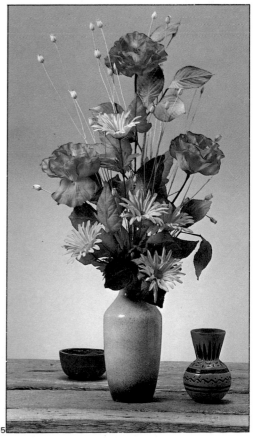

65

Natural and artificial light

An extremely important factor to take into consideration is the lighting of your subject. How do you want to envisage your subject? A strong direct light will produce an intense color contrast between the light and dark areas of the painting, evoking a dramatic atmosphere. A subtle light, which may be filtered by curtains or similar material, allows you to re-create more delicate and subtle shades and tones, evoking an intimate or even melancholic atmosphere.

There are two kinds of light that you may need in your painting: artificial and natural light.

In reality natural light is irreplaceable because the atmosphere it produces around the subject is unique, and the objects and forms illuminated by natural light tend to be richer in color. A window not blocked by a building or any other structure should be considered as your natural light source for painting. A balcony window is ideal;

66

it will give your studio more light and at the same time, allow you the freedom to manipulate the light. If you paint at different times of the day, you will experience an infinite number of possibilities for lighting your subject. You can paint under artificial light with proper lighting fixtures. For certain types of studio work, artificial lighting is sometimes better than natural lighting, because it simplifies the tones and forms of the subject. When illuminated by a well-positioned, potent spotlight, your subject's form will stay in sharp focus. We suggest two moveable spotlights: one for lighting the subject, and the other, fixed to the easel, for the canvas or paper that you will be painting on. It is also recommended that a 100- or 125-watt light bulb be used for your easel, while the other light bulb wattage will depend on your subject and the mood you want to convey.

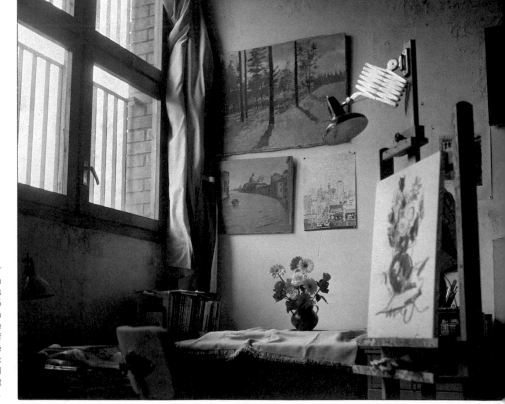

Fig. 66. This is a corner of Parramón's studio in his country house. It has large windows about 5 feet from the floor, with curtains that regulate the direction and intensity of the light entering the room. This is a classic example of zenithal lighting—diffuse light that comes from above.

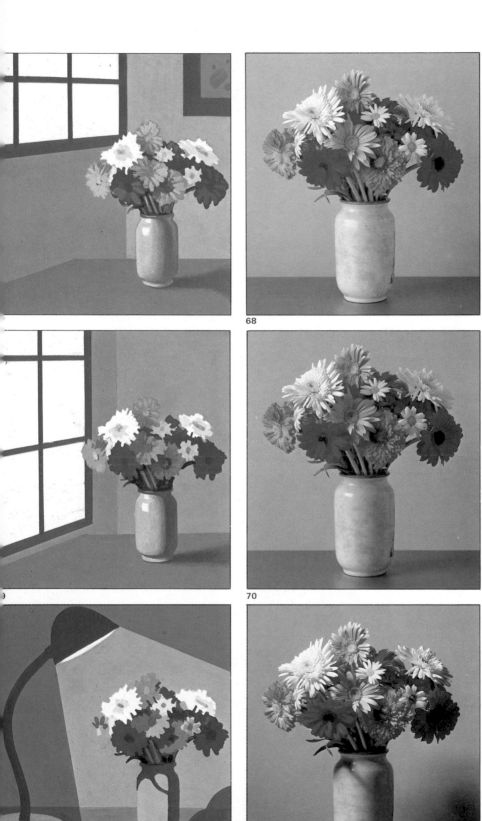

68

70

72

Figs. 67 to 72 (from top to bottom). Lateral lighting coming from a side window where the diffused natural light hits the subject from above. The result is a classic soft image, without great contrasts of light and shade (figs. 67-68). Lateral lighting coming from a side window where the light covers the subject from top to bottom. The lighting is more direct than the first example, giving greater contrast between the lighted and shaded areas of the subject (figs. 69-70). This last example is the result of artificial light from a spotlight. It gives greater contrast and also more clearly defines the border between light and shadow (figs. 71-72). These three *qualities of light* allow the artist to soften or contrast the subject according to his or her needs.

The direction of the light

Another factor you must take into account is, of course, the direction of the light, regardless of wheather it is natural or artificial. The direction of the light will also influence the character of your painting. If you change the position of your light source, you will also change the appearance of your subject's forms quite considerably, which in turn will affect the painting's atmosphere.

Basically, there are four ways to position your lights to illuminate your subject: frontal, lateral, semi-back lighting, and back lighting. Many artists also prefer zenithal lighting, which means that the light is coming from above, from the ceiling or the upper portion of the studio. A variant of this is what we might call zenithal-lateral illumination—an example would be light coming from an open window, the bigger the better—about 6 ½ feet from the floor. Zenithal-lateral illumination allows the artist to paint in optimum conditions.

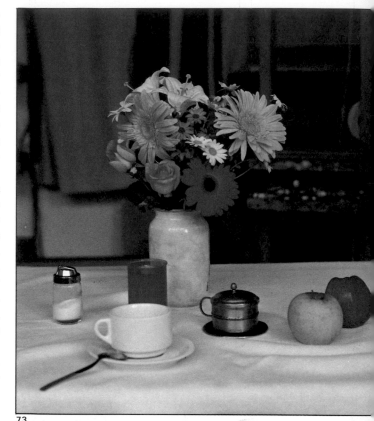

73

Fig. 73. *Frontal lighting:* It is the light direction that offers the most color. The forms are determined by color and can convey extraordinary brightness and contrast, especially if the background is painted with bright saturated colors.

Fig. 74. *Lateral lighting or frontal-lateral lighting.* It is the best lighting for painting the structure and form of the subject. You can see the full *value* range, the lights and shadows.

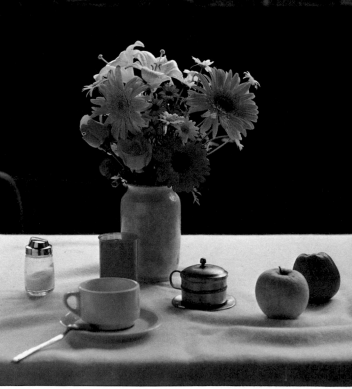

74

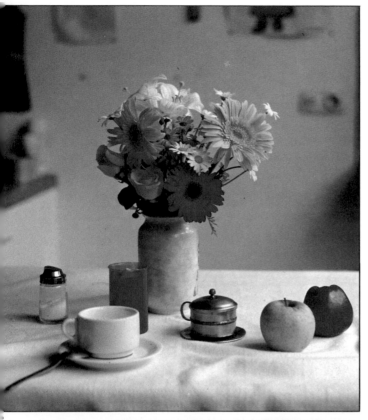

It is not easy today to have a studio with zenithal lighting, but it should not be an obstacle because you can paint in any room of the house you desire. For paintings with subject matter with intense colors, frontal lighting is usually used. In such cases, the forms are determined by their own colors (local colors) due to the lack of shadows produced by the light. In modernism, impressionism, and fauvism, you will see many paintings that used frontal lighting. It is the most popular way for artists to interpret colors, which is ideal for a vase full of flowers.

Lateral lighting or frontal-lateral lighting gives effects of light and shadow that clearly show the volume and forms of the subject. This type of lighting works well for depicting the subject's features.

The delicate effects of semi-back lighting allows you to synthesize the colors and forms of your subject.

Back lighting, when used with sensitivity, is perhaps the best way of expressing a poetic, intimate, or melancholic atmosphere. For floral painting, back lighting can be extremely suggestive and set the mood of the painting.

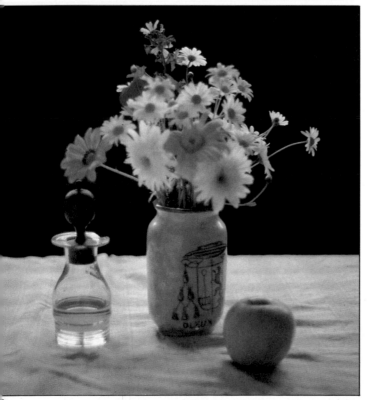

Fig. 75. *Semi-back lighting:* This is a delicate and poetic type of lighting that synthesizes the color and form of the subject. You can achieve good results when the shadows of the subject are not darkened by back lighting.

Fig. 76. *Back lighting:* The light comes directly from behind the subject, thus creating intense shadows that need softening with either a reflecting screen or an additional light. Like the semi-back lighting, this form also gives a poetic and romantic feeling.

Contrasts in tone and color

Color itself has certain light-giving qualities which, when appropriately combined, can create great effects of tonal contrasts. In floral painting it is important to know about certain aspects of color, which without a doubt you will come across when painting. For instance, the axiom of *simultaneous contrast* shows that *a color is much darker when surrounded by a lighter color and, vice versa, a color is much lighter when a darker color surrounds it*.

A *maximum contrast* is produced by the juxtaposition of two colors that complement one another.

It is also interesting and useful to know the principle behind *complementary color induction: to modify a certain color you only have to change the background color that surrounds it*. For example, the green leaves in figures 82 and 83 seem to be bluer on the yellow background and yellower on the purple background.

Another aspect you should also take into account is the general tonality of the painting. This does not mean that in a work of dominant warm tones, you cannot include some cool tones, and vice versa. It is the handling and the way you distribute the tones that determines the character of a painting. Anyway, it is clear that you have an infinite number of possibilities to choose from when you decide on the tones and contrasts for your painting.

* We would like to recommend a book in this same series, *Color Theory,* which explains in more depth the problems related to color.

77

78

79

80

81

Figs. 77 and 78. Y can see in these figur the effect of *simultan ous contrast*. Notice th even though the flowe have the same red col the one on the bla background appears be brighter than t flower on the light bac ground.

Figs. 79 to 81. *Ma mum color contrasts* c be seen in these image Each image has the ju taposition of two cor plementary colors: y low on intense blue, r on cyan blue, a magenta on inten green.

83

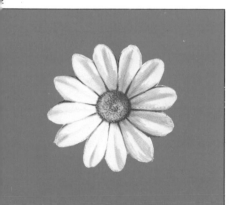

85

Figs. 82 to 85. Here, you can see the effect of *complementary color induction*, where ''to modify a certain color you only have to change the color that surrounds it.'' In effect, you can see that the flower on the green background seems redder than the same flower on the magenta background, which seems greener.

Figs. 86 and 87. Anne Vallayer-Coster, *Flowers in a Blue Porcelain Jar*, private collection, Paris (fig. 86). Charles Reid, *Watercolor Flowers*, illustration from *The Big Book on Artistic Expression*, of which the artist is the author, published by Parramón Ediciones (with permission from the artist and Watson-Guptill Publications).

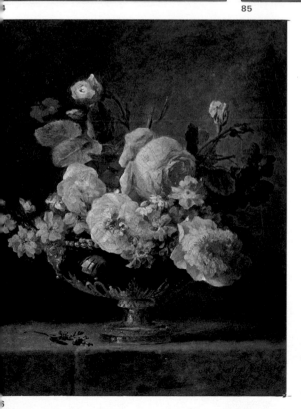

87

47

All the great flower painters were also great draftsmen. Flowers have characteristic forms and specific structures that are used for their identification: The daisy has white petals around a yellow corolla; the rose has its petals wrapped around a bud; and the hydrangea has dozens of smaller flowers grouped together, forming a semisphere. And following the advice of Paul Cézanne, all flowers can be drawn from their basic structures.

In this chapter we will discuss various components of drawing and composition—basic forms and structures, dimensions and proportions, and symmetric and asymmetric compositions.

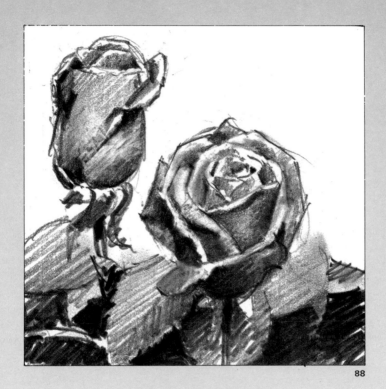

88

DRAWING
AND
COMPOSITION

The importance of drawing

In spite of all the changes and transformations that have taken place in the art world, nobody will argue that *drawing is fundamental to artistic creation.*

In fact, through drawing, any idea or visual thought can be realized. With a few lines and strokes, you can re-create any natural form, or even those fantastic forms from your imagination. By making one or two sketches of the major details of your subject, you can ''see'' how your painting will appear. Drawing is essential for your painting. In one way or another, colors adapt themselves to the subject's forms and structure, forming an indissoluble unity. So, when you know how to draw, you will also be able to apply color with better ability and emphasis, which in the end is what gives a painting its personality.

If you want to paint flowers, it is vital that you know how to draw them individually as well as in bunches to become more familiar with their fragile and perishable constitution. You must become acquainted with, and distinguish between, the characteristics of every flower. In such a way, you will learn more about plants and flowers. Knowing more about their growth and transformation will no doubt enhance your love for them.

Today, there are many different drawing materials on the market. But the traditional materials (charcoal, pencil, pen, and so on) are more than enough to draw flowers and plants with.

Figs. 89 to 94. Remember that all mediums are suitable for drawing or painting flowers. In these pictures, which are all based on the same model, you can see four methods used for drawing and painting: india ink and watercolor, charcoal and pastel, wax crayons, and colored pencils.

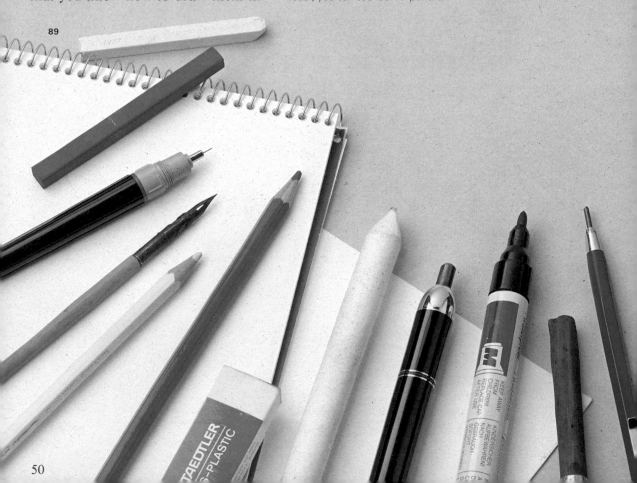

89

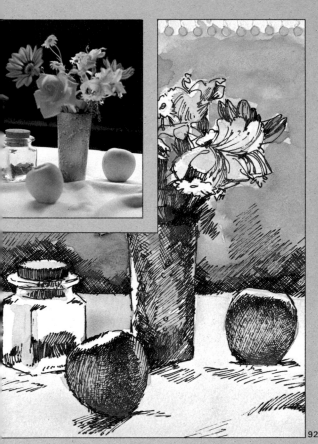

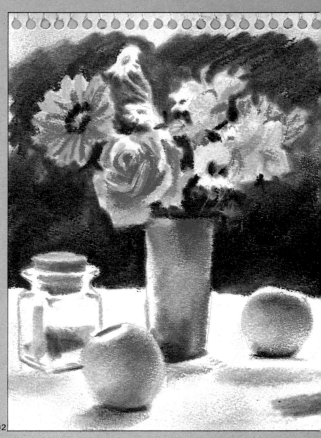

92

94

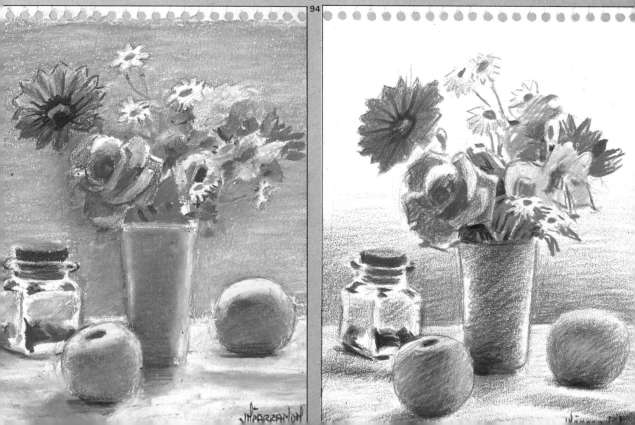

Basic forms and structures

Fig. 95. Paul Cézanne (1839-1906), self-portrait, Louvre Museum, Paris.

Fig. 96. According to Cézanne's theory of basic structures, flowers, jugs, and jars are all round, cylindrical forms.

95

96

Cézanne once said, "In nature, everything is modeled on the cube, cylinder, and sphere. By learning to paint these simple forms, one can do anything he wishes."

If you observe natural forms closely, you will see that most of them can be considered basic geometric structures: cubes, prisms, cylinders, cones, spheres, and so on.

Similarly, the surface area of an object can be reduced to squares, circles, triangles, and so forth.

To be more precise, you can say that all existing forms can be classified into two groups: *bodies with prismatic sides and bodies with curved surfaces.*

This first group is made up of all those bodies with straight sides, or whose volume can be well "enclosed" inside them. So, they are bodies whose fundamental shape is the cube or prism of rectangular sides: of all types of tables and furniture, diverse constructions, and an infinitive number of objects. We are also including all bodies formed by, or that are derived from, pyramids.

When drawing prismatic-sided forms, you will note that the light and shadow zones are clearly defined—the tones are precise and consistent.

The second group is made up of curve-shaped objects that are contained in, or derived from, the cylinder, cone, or sphere: flowers, trees, plants, jars, bottles, and so on.

The main characteristic of these forms lie in the way the light zones fade gradually into the shadow zones, which blends the different tones together, going from the dark zone to the intermediate zone, called half tone, to the light zone. Obviously, this is the group that will enhance your floral paintings. In order to draw and paint flowers and plants effectively—even those with the most complex forms—you should not get lost in the small details. Avoid focusing on the stems and leaves; instead observe the basic structure and analyze the total composition.

To sum up, it is absolutely essential to comprehend the morphological constitution of all the forms you are trying to represent or interpret. If you don't, you will end up copying the subject, void of any kind of artistic expression whatsoever.

Fig. 97. Here, you can see Cézanne's formula applied to various bodies that can be found in floral compositions.

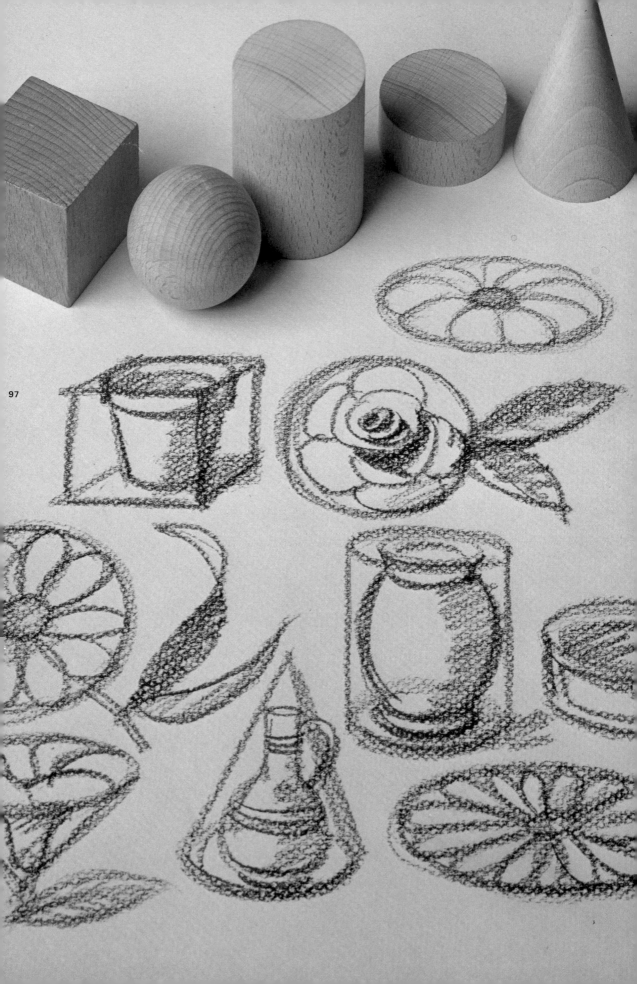

97

Basic forms and structures

Figs. 98 to 105. The French painter Ingres once told his students: "You draw as you paint." Drawing is essential to painting any subject, especially flowers. As you can see in these pictures, the initial floral structures were created with a few basic lines and forms. It is essential to study in depth any problems in dimensions and proportions during the drawing stage. It is also necessary to be precise with the structure and form of the subject, so when you paint the main characteristics, such as the petals, stems, and leaves, they will be easily identified.

After you feel totally comfortable with drawing your subject, you can paint in the form, color and richness of the flower with a few expressive brushstrokes.

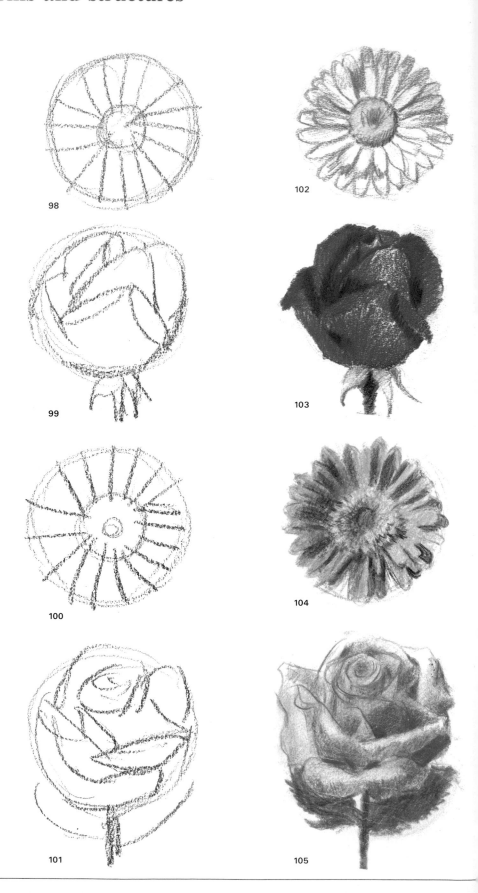

98

99

100

101

102

103

104

105

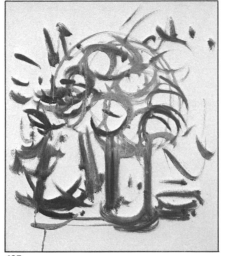

107

6

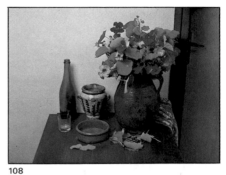

108

gs. 106 to 111. In these aphic examples, you n see the beginning ages of some floral awings. Here, the flow- s are expressed in a w basic forms and lines g. 107). The artist may art with an abstract awing and use it as a ructural reference, to resolve the forms and colors of the subject (fig. 109). Another technique is to begin the painting by drawing the general structure with a series of patches of color; in this method you will have to paint and draw at the same time (figs. 110 and 111).

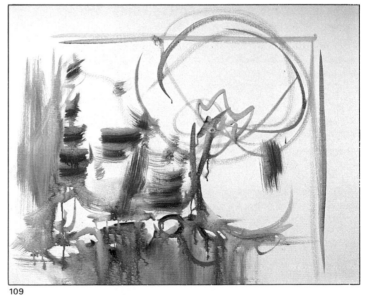

109

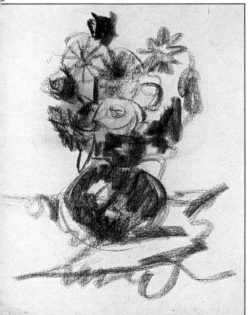

0

111

Dimensions and proportions

Floral theme paintings are usually not done in very large sizes, except if the flowers are included with other subject matter, such as with figures, as part of a landscape, as part of an interior, and so forth. They are usually represented in their actual size, or smaller. Unnatural sizes do not usually suit the humble and simple nature of flowers; the beauty and harmony of their intrinsic forms seem to cry out for a more intimate frame. However, you should feel free to express floral forms in any way you wish, unless by doing so you destroy their defined character with excessive distortion.

The American artist Georgia O'Keeffe deliberately enlarged the size of the flowers she painted by stylizing and simplifying them. With a precise technique, she achieved a naturalism that transcended a mere descriptive enlargement. The Belgian painter René Magritte intregated colossal flowers of precise and realistic forms into unusual settings that created a captivating surrealism.

Nevertheless, it is always important to consider the relative size of the flowers that are to be painted, whatever their role may be—whether it is the main point of focus or part of a group. As we said before, flowers, like any other subject, have characteristic proportions that define themselves.

It should be emphasized that in a simple painting composed of a vase full of flowers, the shape, color, and texture of the vase must be in harmony and in proportion with the flowers, in order to achieve an effective painting.

Figs. 112 and 113. Artists usually paint flowers in their natural sizes, as you can see in Crespo's painting on the right. A detail of the same painting is on the left.

112

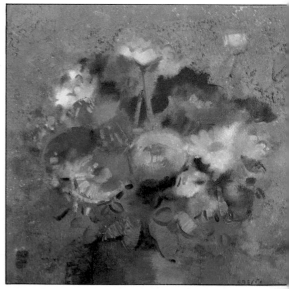

11

Figs. 114 and 115 (top): René Magritte (1898-1967), *The Tomb of the Fighters,* Harry Torczyner collection, New York; (below): Georgia O'Keeffe (1887-1987), *Red Poppy.* Both pictures were painted with oils. Margritte's painting measures 35''×46'' (89×117 cm) and O'Keeffe's poppy is 7¼''×9'' (18.4×22.8 cm).

115

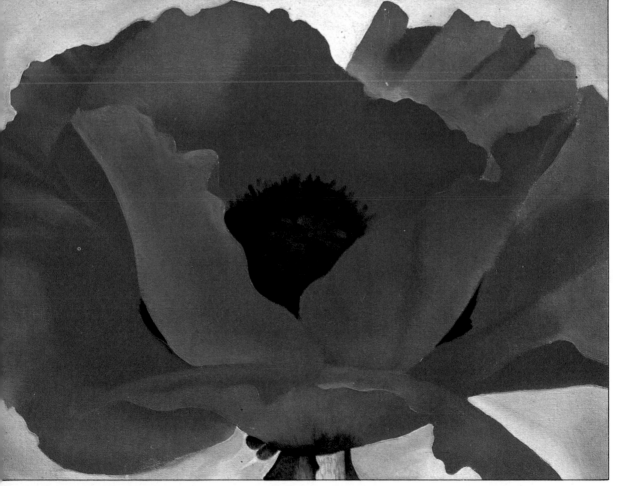

The composition always exists

A composition is the combination of elements that unify a harmonious group of visual characteristics to form a picture.

Even in a simple composition of a vase with a single humble flower, you would establish the relationship among all the different parts (petals, stem, leaves, the vase, the stand, and the background or surroundings). The size and proportion of the canvas or paper you are going to use is also a factor that will determine the outcome of your composition.

Clearly, the composition is an important aspect that should be given careful attention. But it is also true that in modern painting, almost since impresionism, there is much freedom to experiment in this area. There is no doubt that a good part of a painting's character and originality rests in the composition, and it is also true that serious work and study allow each artist to develop it in a natural and logical way. When the Greek philosopher Plato—4th century B.C.—was asked by his disciples what composition meant to him, he simply replied: *Unity in variety, variety in unity.''* That quote by Plato is probably still the best definition of artistic composition. In practice, composition means the placement of different elements that make up a painting—its colors, forms, background, and so on. A successful composition possesses such variety and richness that it makes the viewer contemplate and take delight in the painting. Variety does not come easily; you need the ability to know how to order different forms and colors into a harmonious group.

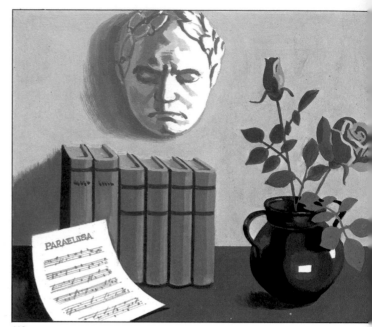

116

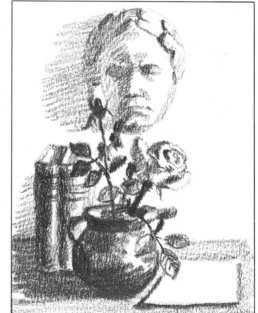

117

Fig. 116. From the o jects in this figure, mask of Beethoven face, some books, music parchment, a some roses in a vas you are going to stu different compositior for a painting that y could call *Homage Beethoven*.

Fig. 117. In this first tempt, you can see th the symmetry does r benefit the picture composition.

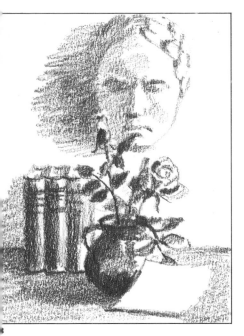

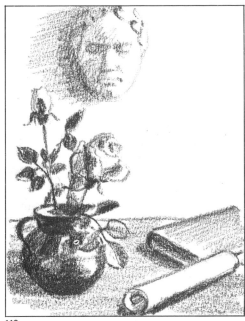

119

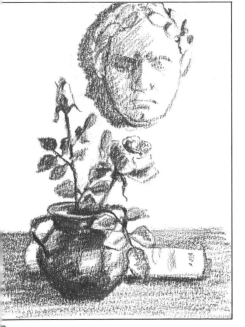

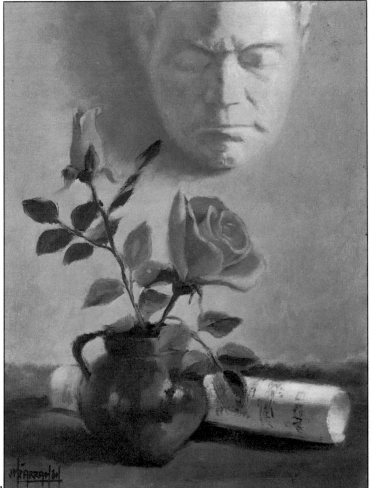

Figs. 118 to 121. You can see the progression made through these pencil sketches. The last sketch eliminates the books and synthesizes the idea of "homage to Beethoven," with the mask and parchment behind the vase of roses. Notice how the final sketch corresponds to the painting.

121

Cézanne and the art of composition

The great French painter Paul Cézanne is considered by many to be the father of modern painting. He prepared his compositions with extreme care and patience over long periods of time. In his still life paintings, he took every detail into account. He moved the objects around on the table, studied forms and complementary colors in order to obtain maximum contrasts, and even calculated the effects produced by creases in fabric. Cézanne was a real master of composition. Once when he was asked what rules of composition he applied to his paintings, he flatly replied that there were none.

A composition is based mainly on intuitive impulses. Before you begin painting you have outlined in your head how you want to see the forms and colors of your subject on the canvas. Your personal feelings and sensations toward the subject are the creative force behind a painting.

Figs. 122 and 123. Paul Cézanne (1839-1906), *Carafe Still Life*, Tate Gallery, London. It is well known that Cézanne studied the forms, the colors, and the exact positions of his objects when composing his still life paintings. He also structured his pictures with linear sketches before painting, to study and reaffirm the theme of the composition.

122

123

Symmetry

124

> **Symmetry is the equal distribution of a painting's elements on each side of a central point or axis.**

Many great paintings in art history follow the concept of symmetrical composition.

Symmetry was the first organizational formula used during the Renaissance. The masters of that time, such as Leonardo da Vinci, Michelangelo, and Raphael, used symmetry in their paintings without reservation. It is a safe procedure, because an equilibrium of elements and masses guarantees a harmonious effect.

You shouldn't think that symmetrical composition is out of date, because many contemporary artists still make use of it, especially for floral themes. Also, you shouldn't think of symmetrical compositions as giving cold or monotonous results. For flower paintings, the variety of the colors of the flowers, the arrangement, the stems and leaves, as well as the background will help you eliminate the risk of making a uniform or monochromatic composition. You can also include other objects and forms to complement the flowers—for example, ceramics, glass ornaments, books, and even loose leaves from the flowers you want to paint. A composition does not have to be rigid and its theory should not be taken literally.

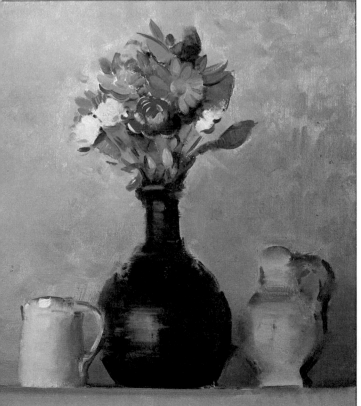

Figs. 124 and 125. The idea of symmetry can be seen in figure 124, where the image is structured around a central axis. A freer composition is also possible, in which the central axis unity still predominates but with the diversity of other elements added to the basic theme. This is a solution adopted by Francesc Crespo. The result is reproduced at the bottom of this page.

Asymmetry and the Golden Section

Asymmetry is the free or intuitive distribution of the elements of a painting, balancing the different areas in order to achieve a harmonious unity.

Many artists use the asymmetric composition to express themselves without the restriction of laws or norms. However, as it is stated in the above definition, the idea of balancing areas of a painting to achieve group unity must also be applied to the forms and colors of a painting. In fact, it would be far from the spirit of painting to approach a canvas with total anarchy and neglect, thinking that some simple brushstrokes will achieve acceptable results.

All compositions must have an equilibrium among their elements, otherwise the objective to achieve *a satisfactory visual unity* cannot be reached.

In an asymmetric composition the superimposition of several forms, situated one in front of the other, is commonly used to create a series of successive planes that leads to the attainment of unity.

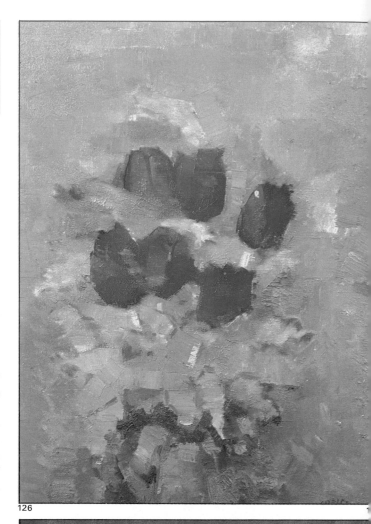

126

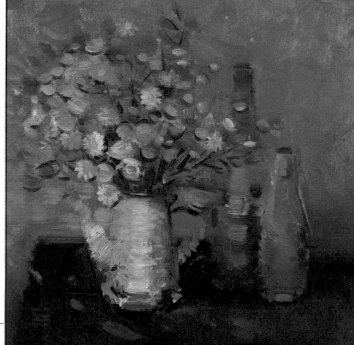

Figs. 126 and 127. In these paintings by Crespo, the artist has chosen an asymmetric composition, placing the focal point, the jug of flowers, to one side.

The Golden Section

The *law of the Golden Section* was discovered by the Greek mathematician Euclid:

"If a space is to be aesthetically pleasing when it is divided into unequal parts, there should be the same relationship between the smallest and largest parts that exists between the largest part and the whole."

The key factor is .618. If the width and height of a linear painting are multiplied by 0.618, you obtain two lines (A and B) and a point of intersection—the compo-

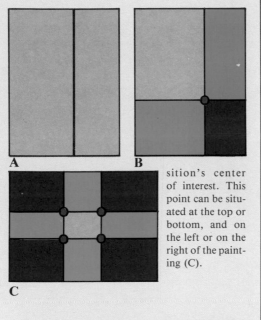

A B

C

sition's center of interest. This point can be situated at the top or bottom, and on the left or on the right of the painting (C).

Perhaps the most universal rule or norm of composition known is the Golden Section. It is very old and has been employed in one way or another, consciously or not, throughout time. The formula is as follows:

> **If a space is to be aesthetically pleasing when it is divided into unequal parts, there should be the same relationship between the smallest and largest parts that exists between the largest part and the whole.**

Let's take a straight line segment whose total length is 5 inches. If you divide this size into 2 and 3 inches, you immediately establish that nearly the same relationship exists between the smallest part (2) and the largest part (3) as between the largest part (3) and the whole, or total, length (5). The numerical ratio of the greater segment of the line to the shorter segment, as determined by the Golden Section, has an approximate value of 1.618.

To obtain a harmonious Golden Section division in any rectangular surface, you multiply the width of the paper or canvas by the factor 0.618. And when you multiply the height of the paper or canvas by 0.618, you will create an ideal point—where the width and height lines intersect. The most important elements of your painting should be placed at this ideal point of intersection.

The Golden Section is a law of composition that is explained by nature; this is the reason why it remains valid. For many people, this proportional relationship is found in nature itself: in the animal and vegetable world and in the dimensions of the human body.

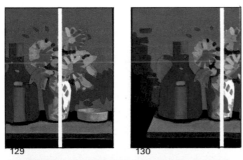

129 130

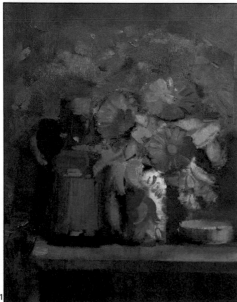

131

Figs. 129 to 131. Here, you see a practical example of the Golden Section: In the top paintings, you can see that the compositions are greatly disproportionate: there is excessive unity in one painting (fig. 129) and excessive diversity in the other (fig. 130). The reproduction by Crespo at the bottom has the jug of flowers positioned in the right place, as defined by the Golden Section theory.

An important and positive
factor in the art of painting
flowers is the fact that you,
the artist, choose and
compose the subject. You
determine the vase's shape
and the objects that
accompany that vase. The
background and its colors,
the color of the vase, and
the flowers are your choice.
Before you begin painting,
you can decide on the color
harmonization for your
painting by choosing and
composing a range of
warm, cool, and broken
colors.

132

COLOR
HARMONIZATION

Value and color

No true artist has ever limited himself or herself to just "copying nature" or "copying the subject." Maurice Denis, a French painter and friend of Cézanne, said: "Before a painting is a battle steed, a nude, or an anecdotal thing, it is essentially a flat surface covered with color, according to a certain order."

Even before having the theme and subject, the artist must plan and imagine a determined color tendency. An artist must plan or organize a painting according to his or her own aesthetic conceptions. Pierre Bonnard explained that in principle a painting must be *an idea,* and went on to say: "I tried to paint some roses in my own way, but I got caught up in the detail... I then noticed I was not getting anywhere; I tried to recapture my first impulse, the vision that had dazzled me so much." Without a doubt, there is nothing as subjective as color; it is, of course, a complex matter, but to simplify it you should think in terms of *value* and *color*.

If value is the main emphasis of your painting, you need to adjust the color of your subject according to the conditions of the light and shade that are present. The light and shade help the artist determine the volume of the forms of the subject to produce a chiaroscuro. In general, you can say that value drawing was imperative to all the "classical" painters, from the Renaissance to impressionism.

On the other hand, if the colors of your subject are what you want to emphasize, then you need to employ very concrete tones and shades. You need to visualize and differentiate the volume of your subject through flat colored patches. You can find many examples of this color tendency in modern painting.

Fig. 133. José M. Parramón, *Three Roses*, private collection. This is a classic example of a *value* painting. The theme is treated with a maximum contrast of light and shadow, and the volume of the flowers is produced with tonal values.

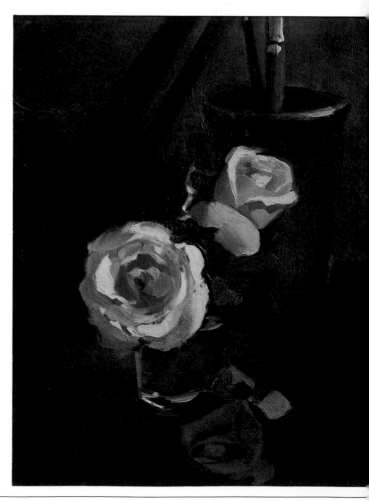

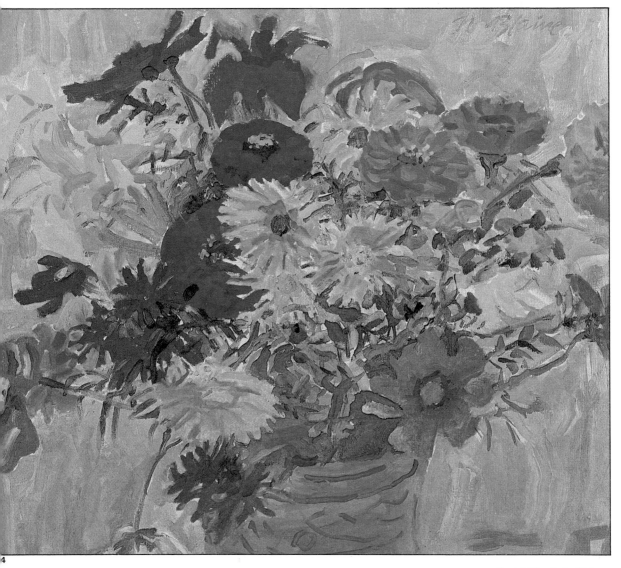

4

Fig. 134. Nell Blaine, *Bunch of Flowers*, private collection. In this *color* painting, the forms of the flowers are created with almost flat colors.

The harmonic range of warm colors

If red and yellow and all the tones of these two colors were used in a painting, you could say that the painting had a *harmonic range of warm colors*. The warm color range is essentially made up of the following colors.

> **Violet, magenta, crimson, red, orange, yellow, and light green.**

In figure 135, you will see a predominantly *warm palette* made up of warm and cool colors.

As you may already know, you can substitute the light cobalt blue with a cerulean blue, the permanent green with a sap green, or a different tone of violet can be added. In any case, when you mix the cool colors with the reds, oranges, and yellows, you will notice how "browns" develop from the mixed colors, maintaining a relationship with the *harmonic range of warm colors*. It is important to remember that in art, you must never take the rules and theories as absolute gospel. The bright colors of a great majority of flowers (intense reds and yellows,

orange-pinks, crimson tones and yellow-greens of the stems and leaves) integrate extraordinarily well into warm compositions and tones. Perhaps it is in the floral theme that you can use the brightest tones, without being afraid of going too far. In fact, the "secret" for immediate success and acceptance of many floral paintings is due to the joy and irresistible attraction of its colors.

135

Fig. 135. A palette with a selection of oil colors, consisting predominantly of warm colors, such as oranges, ochres, siennas, reds, carmines, and so forth.

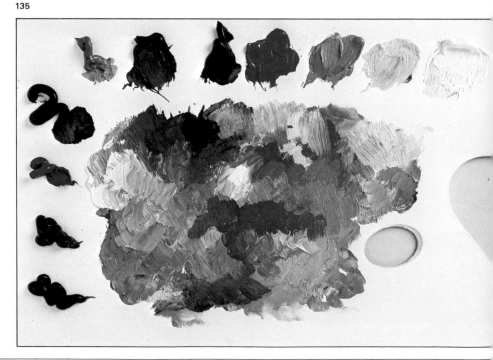

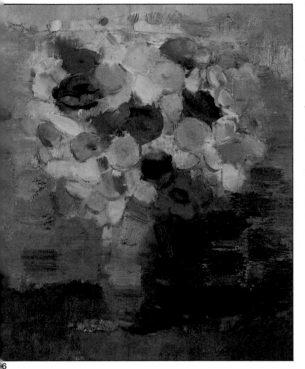

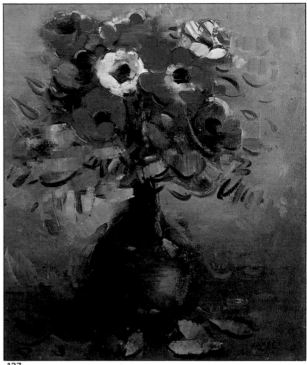

137

Figs. 136 to 138. In these paintings, Crespo used a range of warm colors, as well as some greens that at certain points give bluish tones. These examples demonstrate that a color range does not have to be rigid and exclusive.

139

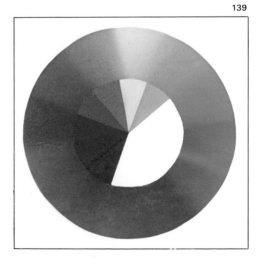

Fig. 139. In this color wheel, you can see the primary, secondary, and tertiary colors that have a warm tendency.

The harmonic range of cool colors

When the principal colors of a painting are blues and greens, or tones derived from those two colors, you could say that the painting is toned in the *harmonic range of cool colors*.
Below are the colors that essentially make up the cool color range.

> **Green, light green, dark green, cyan blue, ultramarine blue, dark blue, and violet.**

But in practice, a cool palette does not need to exclude a warm range color, such as red or yellow. The predominantly *cool palette* you see in figure 140 contains both cool and warm colors. You can also easily substitute the cadmium yellow with a cadmium lemon yellow, the cadmium red light with an orange, and even raw umber with a burnt sienna. In one way or another, however, these warm colors should always be mixed to harmonize with the blue or green shades.

In similar ways as the warm range of colors, the harmonic range of cool colors offers you an abundance of possibilities when painting floral themes. In general, bright warm colored flowers need contrasting cool and complementary tones for emphasis. You can create suggestive and expressive results by contrasting your warm and cool colors. There are also flowers that are suited for the cool range—delicate violet and purple flowers, blue flowers, and even black flowers.
In floral paintings, the harmony obtained from varying cool tones will help create a serene and elegant character.

140

Fig. 140. A palette with a selection of oil colors, consisting predominantly of cool colors, such as blues, greens, and so forth.

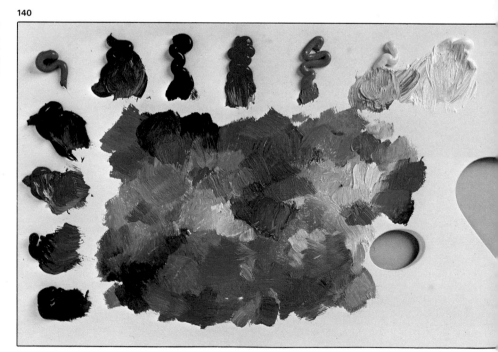

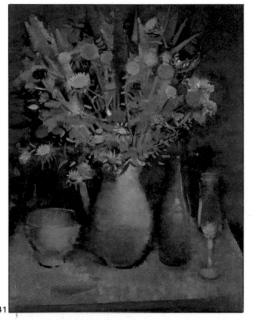

141

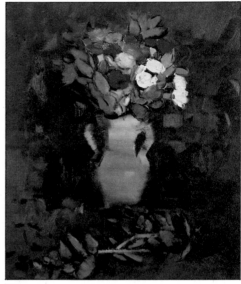

142

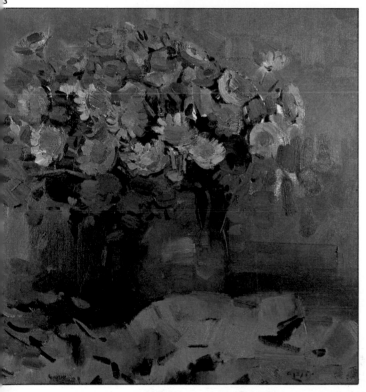

3

Figs. 141 to 143. For these paintings, Crespo used predominantly a cool range of colors—blues, grays, greens, and purples. The forms, however, have a warm color tendency even though the general harmonization is of cool colors.

144

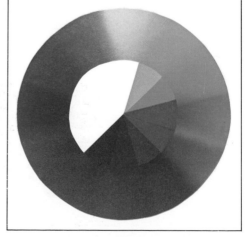

Fig. 144. In this color wheel, you can see the primary, secondary, and tertiary colors that have a cool tendency.

The harmonic range of broken colors

A *harmonic range of broken colors* (sometimes called neutral colors) can be obtained through a subtle *graying* of colors. You can compose a range of broken colors by mixing complementary colors, in unequal parts, with white.

For example, if you take the two complementary colors permanent green and cadmium red light, and mix the green with more or less the same quantity of red, and then add some white, you will get a grayish or "dirty" broken color: greenish ochre, khaki "brown." The higher quantity of color there is in respect to the other, the darker its tone is; the more white that is added, the more accentuated the *broken* grayish color will be in each new tone. In any case, you will obtain a beautiful, unique shade.

Throughout history, many great paintings have been developed from the range of broken colors. In fact, there are many who believe that a "great painting" should be composed main-ly of grays—either warm or cool in tendency—to induce a contrast with the bright colors of the composition. When you go to art exhibitions, it is good practice to study the general chromatic harmony of the paintings on view. Try to figure out if a painting has a cool, warm, or broken range.

Figs. 146 and 147. F these paintings, Cres used the range of brok colors in cool and war tones.

Fig. 145. This palette of broken colors was basically composed by mixing unequal parts of complementary colors and white.

145

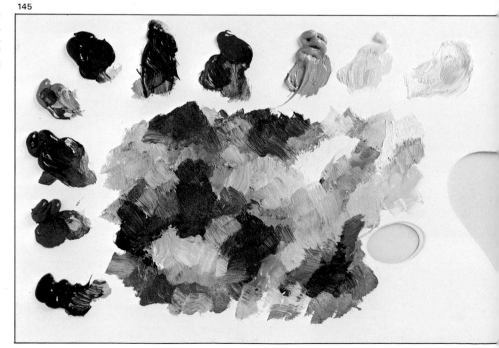

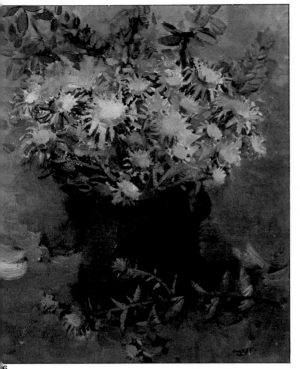

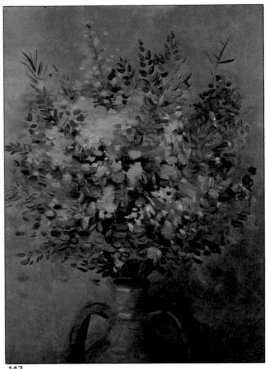

147

Fig. 148. Parramón creates a watercolor luminosity in this painting with a range of dirty broken colors.

Fig. 149. This color wheel shows possible mixtures of cool and warm complementary colors to get broken colors.

149

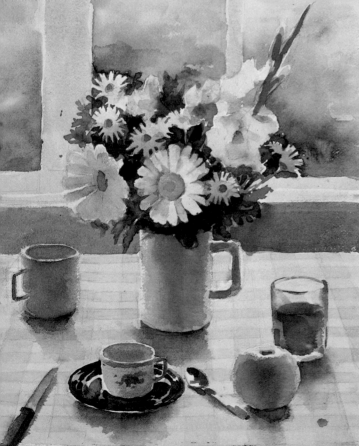

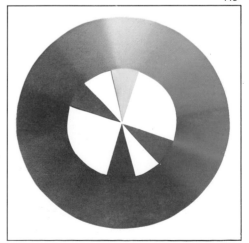

148

This chapter contains five step-by-step demonstrations of floral paintings. A variety of media was used, such as pastels, colored pencils, oils, and watercolors, to give you an idea of how diverse you can make your flower painting.

Some of the information was compiled in the studio of Francesc Crespo. While Crespo was painting, I, José M. Parramón, sat next to him, taking notes and dictating into a cassette recorder. In this book I explain what materials Crespo is using, how he starts a painting, the colors he applies first and then later, how he paints the leaves and petals, and in short how to paint flowers. Also present while Crespo painted and I dictated was a photographer capturing all the different stages.

There are also some step-by-step demonstrations of my paintings. Together, we hope to supply varied approaches that will act as teaching guides.

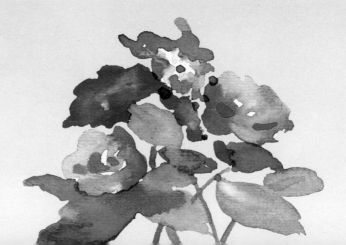

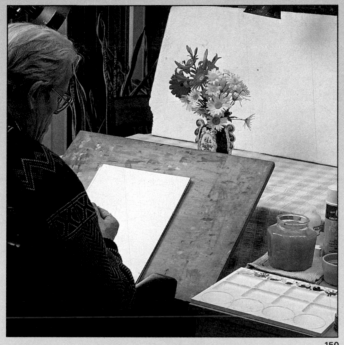
150

PAINTING
FLOWERS
IN PRACTICE

Crespo paints a picture with pastels

In this chapter, Francesc Crespo and I will guide you through several step-by-step demonstrations of paintings rendered with pastels, colored pencils, oils, and watercolor. You will witness the process of each painting from start to finish.

The first painting by Crespo of some white daisies and roses in a jug was done in pastel.

Crespo is an expert in painting flowers. He knows all the tricks and secrets, from working with a particular color range to regulating the temperature of the studio in order to keep the fresh-cut flowers open.

To begin, Crespo chooses a sheet of 27" × 20" (70 x 50 cm) white paper and a selection of 180 Rembrandt colors. As you can see in the pictures, next to his easel, Crespo has an auxiliary table on wheels with various drawers. On top of the table are two trays with Rembrandt colors. Next to the two trays,

you can see two smaller trays in which he keeps his colored stubs—the top tray contains the cool colors and the bottom tray contains the warm colors. The stubs that Crespo plans to use for this specific painting are placed in a box in front of the two trays, so that he does not have to look for them again.

Now let's see how Crespo begins this painting.

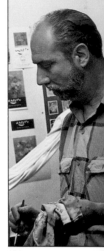

151

Fig. 151. France[s] Crespo, professor at t[he] Fine Arts Faculty [of] Barcelona, in his stud[io.] Many of his oil a[nd] pastel flower paintin[gs] have been presented [at] various exhibitions.

152

153

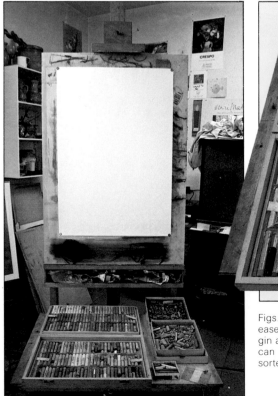

Figs. 152 and 153. Here is Crespo's easel with drawing paper ready to begin a floral painting. In front of it you can see a box of 180 pastel colors sorted in warm and cool ranges.

First stage: making the basic structure

First we must observe the model and mentally calculate the width and height of the jar and flowers, so we can determine the setting, background, space around the model, jar and the flowers, and how it will look on paper..." Crespo stops here and starts to draw, with a piece of dark gray chalk, a series of circles where the flowers will be placed—one circle, one flower (fig. 154). Quickly and confidently, like someone who knows the lesson well, Crespo finishes drawing the jar and flowers. Now, with a piece of English red pastel, he starts to paint the background (fig. 155). You will observe in the other paintings that the process of filling up the paper is a method that Crespo uses consistently. Crespo explains, "It is an urgent necessity to balance the contrast and determine a concrete color. It is essential to know the background color; you have to take into account the law of simultaneous contrast that states: *a color is much darker when surrounded by a lighter color and vice versa.*"

But this is still the initial stage of the painting and what concerns Crespo at this moment is the color. First he begins to paint the corollas of the daisies with dark yellow, then he draws lines for the petals using dark gray chalk (see page 78), trying to put the flowers in their right place and give the accurate proportion to the shapes, leaves, and shadows of the flowers.

Figs. 154 and 155. Crespo begins by drawing large strokes, creating flowers from circles. At this stage his major concern is to combine these forms into a composition, without going into details, such as the leaves, petals, or corollas.

155

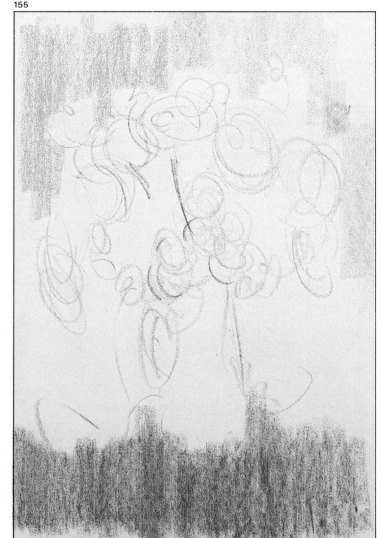

Second stage: painting over a good drawing

A good painter needs to know various mediums, different techniques, and the art of drawing.

It is not possible to paint without drawing. This idea has been repeated many times, but was most clearly stated when Ingres said, "You paint as you draw."

As you will see in this painting process, Crespo paints as he draws, using pastels.

Crespo organizes his composition by drawing the flower forms—leaf by leaf, petal by petal—with concrete lines and shading, responding exactly to the subject's forms.

As I watch him, it seems, at first, that he is more concerned about the form rather than the color. But then Crespo quickly begins to apply the colors, one after the other, slowly eliminating the lines of the drawing. At this point, Crespo lets loose to invent and create. This is how a painter should work with pastel. Pastel colors allow you to paint light over dark—up to a certain point. With pastels, the artist paints directly on the surface, hardly ever needing to mix colors. Crespo paints over a perfect drawing with the wide range of pastel colors and shades at his disposal.

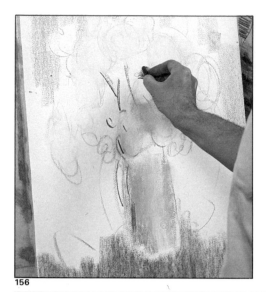

156

Figs. 156 to 158. Now, he continues with more concrete strokes and begins to draw specific forms, alternating the drawing with colored patches that he stumps with his fingers, merging and blurring the forms.

157

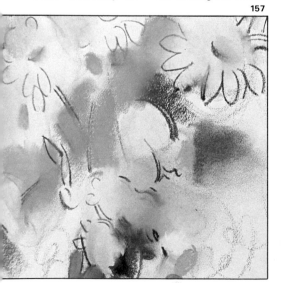

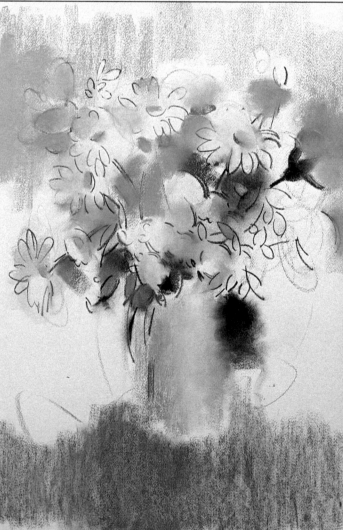

Third stage: painting the background

u can see in these pictures that
espo is nearing the final stages of
s painting. Notice the cloth in
espo's left hand in figure 160. You
:d a cloth while working with pastels
:ause they tend to break and mix
h other colors as you apply them on
per. Also, when you leave pieces of
stels in auxiliary drawers (see fig.
3), the individual colors can get cov-
d with a variety of other colors. You
:n need to clean your pastel sticks
h a cloth—a quick touch is enough.
other way to resolve this problem
to scrape the other color off

on one of the margins of your support
board (fig. 161).
In this stage Crespo needs to paint in
the background. He looks through the
selection of pastels in the warm range
and chooses a salmon, a gray ochre,
an English red, and black. If you look
at figures 162 to 165, you will see how
Crespo paints in the background—
using his fingers to stump in the color.

Figs. 159 to 165. In
these pictures you can
see some of the tech-
niques Crespo uses for
painting with pastels:
Cleaning the pastel stubs
and his fingers with a
cloth after every stroke
and stump, in order to
get cleaner colors (fig.
160); testing the color of
the pastel on the edge of
the board (fig. 161); su-
perimposing colors, us-
ing pastel stubs (fig.
162); stumping with all
of his fingers (figs. 163
to 165).

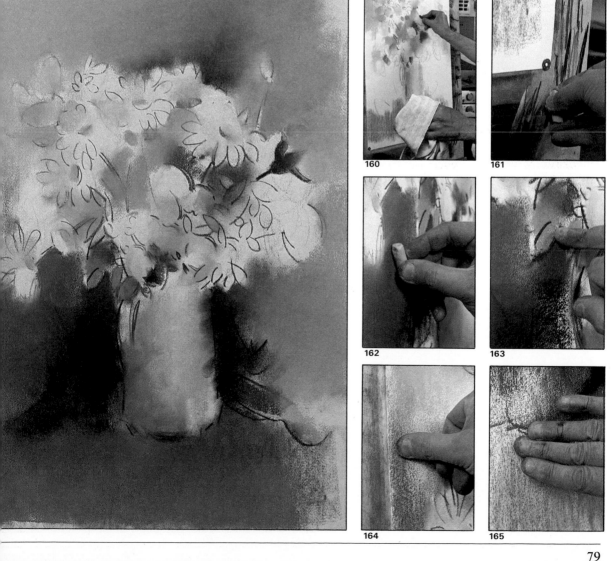

160 161

162 163

164 165

Fourth and final stage: brushstrokes and stumping

Crespo continues painting and stumping with his fingers, superimposing and mixing colors. Remember, it is important to clean the pastel pieces and your fingers with a cloth. Crespo advises, "Beware when you are going from one zone to the next; don't get confused and let your picture turn into a symphony of gray colors." One thing I noticed about Crespo's work habits is that he never uses an eraser or cloth to correct errors. Crespo confirmed this by saying, "No. Now and again I use the malleable eraser. Thanks to this modern eraser you can open up white parts where a petal or a thin branch is and correct the error. But I think this way of painting is a more meticulous style, maybe hyperrealistic; it is not meant for this fresh, loose style which is close to impressionism. And as you know, it is much better to paint over the error rather than use a cloth or an eraser."

We are now in the last stage of the painting. Crespo is concentrating and then goes through the motions of painting again: stumping with his fingers, cleaning the pieces of pastel and his fingers with a cloth, looking back at the model again, painting, stumping ... over and over again.

The last phase of this lesson requires that you reviw the progressive development of the painting, checking that Crespo has worked with the group as a whole. At this moment, Crespo interrupts my dictation, and looks at me

smiling: "Let me finish, Parramón; this is an idea I often explain to my students in my drawing classes at the Fine Arts Faculty:

"The parts have to be subject to everything. The work has to advance progressively. In no case should a part or detail have a superior value over the group. The painting must be worked on all at the same time."

166

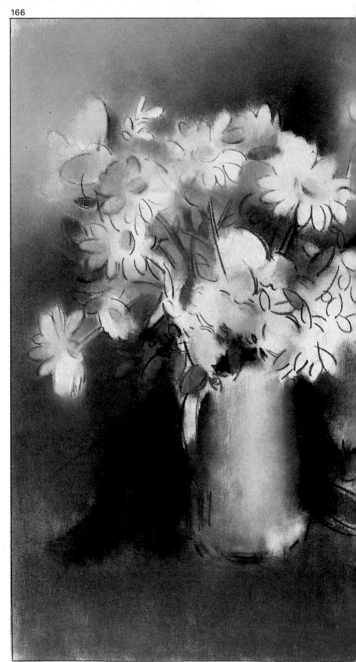

Figs. 166 and 167. These two stages of the same painting perfectly illustrate Crespo's idea, which he stated after finishing the painting: "The parts have to be subject to everything. The painting must be worked on all at the same time."

167

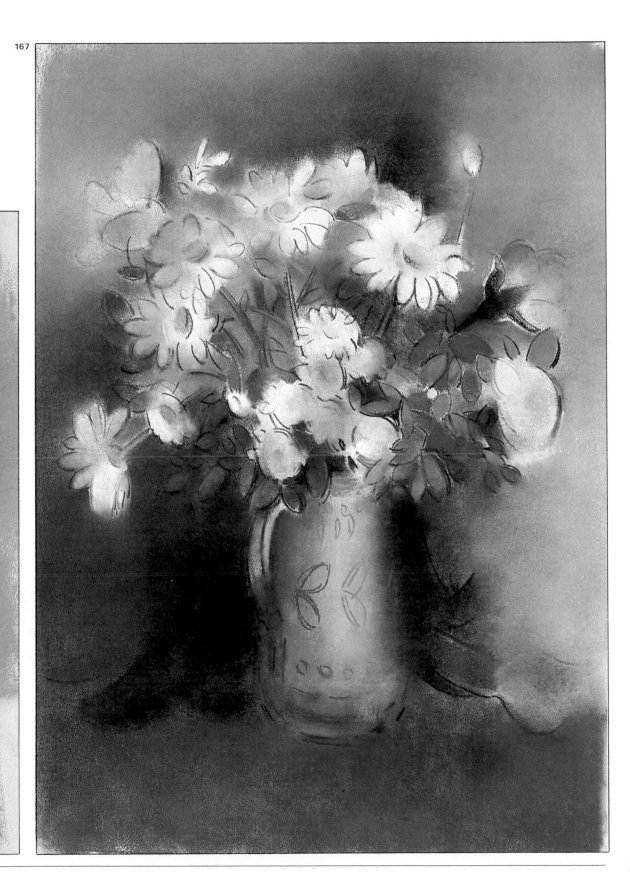

Parramón paints a picture with colored pencils

Colored pencils are generally associated with children's drawings and artistic works of little importance. However, when they first appeared toward the end of the 19th century, they were used by the impressionists to make rough drawings of landscapes. Toulouse-Lautrec used them for a variety of purposes, including his drawings of dancers and singers of the Paris cabarets. In this century, many famous painters have drawn and painted with colored pencils, such as the Austrian Gustav Klimt, the Belgian Fernand Khnopff, and the Englishman David Hockney. I have written a book in this same series about the techniques and possibilities of this medium, *How to Paint with Colored Pencils*. I believe that colored pencils are an ideal way of learning how to paint, precisely because they are *pencils:* a well-known medium that unlike the palette knife, the brush, and paint, is not new to the beginner. Colored pencils also allow you to concentrate on the basic problems of mixing and composing colors, in short, *understanding* color.

168

169

170

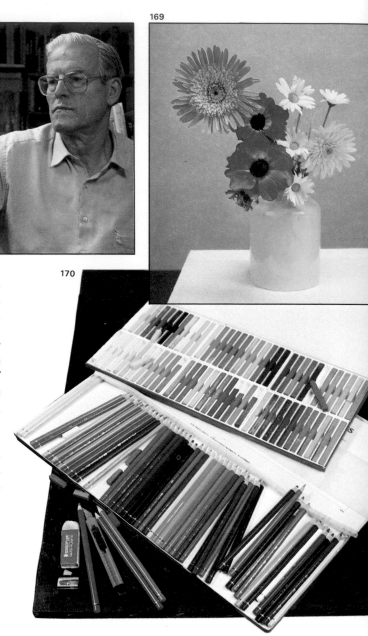

Fig. 168. José M. Parramón, professor of drawing and painting and author of more than thirty books on art techniques, has drawn with colored pencils on many occasions. "It is a simple medium, but it offers many possibilities, especially in the art of painting flowers," says Parramón.

Fig. 169. This still life has the kind of flowers whose forms and colors are especially suited for drawing-painting with colored pencils. In effect the daisies and orange and yellow flowers present a certain drawing complexity, but at the same time the colors of the flowers offer a bright harmonious contrast.

Fig. 170. Here, you can see an excellent selection of seventy-two colors manufactured by Cumberland. These all-lead sticks are especially made for painting backgrounds and wide surfaces. Below the Cumberland colors is a pencil box containing sixty colored pencils by Faber-Castell. The supplementary materials in

the lower left-hand corner include an eraser, a pencil sharpener, and a blade, for opening and scraping whites.

Figs. 171 and 173. A previous linear drawing is used to structure the floral shapes and to organize the composition.

Fig. 172. In this fi stage I am painting in general color of ea flower, with the flat s face of an all-lead sti

Fig. 174. When usi professional colors, y may need to hold ten more colors in one har as you see here, a paint with one color the other hand.

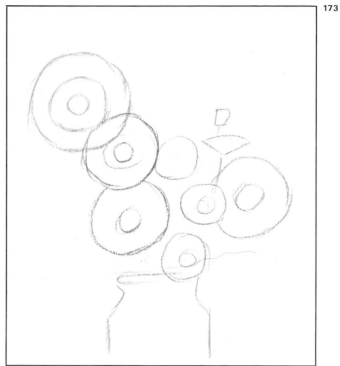

173

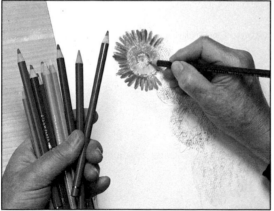

174

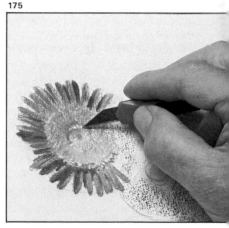

175

Fig. 175. If you paint in an area with a light color like yellow and then paint a darker color over it, you can use a cutter to scrape the top color to open up the white or light colors; this is known as painting "in negative."

Fig. 176. Here, I am painting in the background gray, using the flat edge of an all-lead pencil.

Fig. 177. At this stage I am drawing in the contours of the red flower with thick strokes; then I will paint the local color of the flower using the same pencil.

176

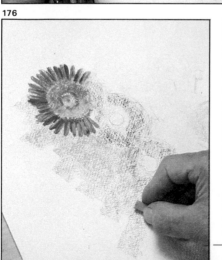

177

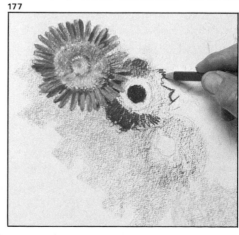

Drawing and painting in stages

If you look at figure 178, you may think that it is an error, or contradiction, to the rule that has been repeated so many times in this series; *Do everything at the same time; work on all parts of the painting at the same time, work on it progressively.* This is no error, only an exception to the rule. The rule is valid to avoid errors in contrast and color, especially when painting in opaque mediums, such as oils and pastels. Those mediums allow you to paint over and modify colors, as well as paint light colors over dark colors. Painting *alla prima,* where you resolve forms and colors *right away,* without regrets or repainting, can also be valid. For instance, when painting with watercolors you need to get the color right on the first coat without having to go back over it later.

Since pencil is not an opaque medium, you cannot paint a light color over a dark color. It is also a medium that cannot be stumped as lead pencil, charcoal, sanguine, and pastel can be. With colored pencils, you must paint stroke by stroke and line by line. Generally speaking, colored pencils are not a medium for painting on large surfaces; therefore, it is not advisable to paint in the background when using this medium. Leave it as the color of the paper—white, cream, or gray.

The flowers that I have painted here are on a white or light gray background, so there is no problem with *successive contrasts* produced from color juxtapositions, especially in the background. Since size was not a factor in this painting, I was not obliged to see and do everything at the same time.

Remember, art has no absolute rules. My advice for working with colored pencils is to paint ''from less to more,'' everything at the same time. And in this case, I painted *everything at the same time* but *in the first attempt.* The French artist Jean Baptiste Camille Corot created paintings step by step, in a most complete way, on the first

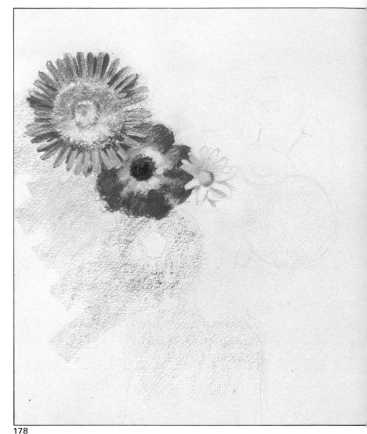

178

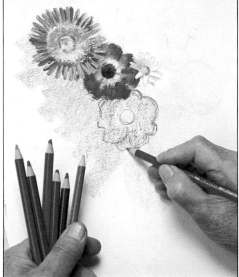

179

Figs. 178 and 179. these pictures you c see the process of pai ing from less to mo which means that eve thing is painted at t same time. Certain are of the picture I resolv by drawing-painting.

Fig. 180. "In order to obtain maximum output with minimum effort," as production experts would say, I advise you to use a pencil sharpener instead of a blade, which takes longer and uses up more energy and concentration. The long cone-shaped sharpeners are the best ones to use.

Figs. 181 and 182. With a selection of seventy-two different colored pencils, you can generally paint without the need of mixing colors. However, there are times when it is absolutely necessary to mix, and one of those times is now. In order to get this carmine-violet-purple, I first apply a coat of cobalt blue light and then a coat of purple light, just as you can see in these two figures.

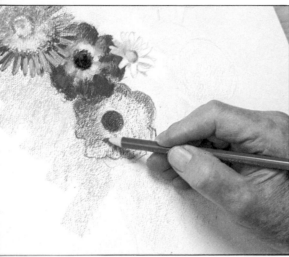

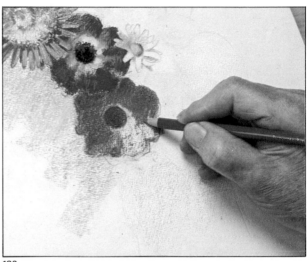

182

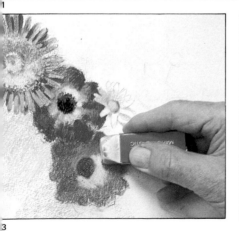

3

184

Fig 183. Good-quality colored pencils allow you to rub out an image by using an eraser. You must rub firmly to regain the white of the paper. Do not be afraid to use an eraser; it is a perfectly valid tool.

Fig. 184. While you are painting and drawing with colored pencils, it is useful to have a piece of scrap paper nearby, similar in quality to the type you are using for your painting, so you can test the colors and shades before applying them to your picture.

y, leaving very little left to do when had covered the whole canvas. orot confirmed his method of painting by saying: "I have observed that erything that is created directly is more pleasing and natural; in this way, we hope for a happy accident, in contrast to repainting that usually loses the harmony of the first tonality."

Drawing-painting, or the drawing as a first stage for a picture

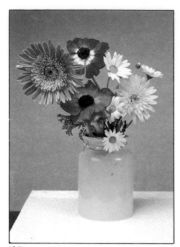

185

Figs. 185 and 186. Because the flowers are starting to lose their vitality, especially the red anemones, I want to begin painting the green stems and leaves. I lift up the entire bunch of flowers to separate them from the jar in order to get a better view of the stems and leaves and begin to paint with green.

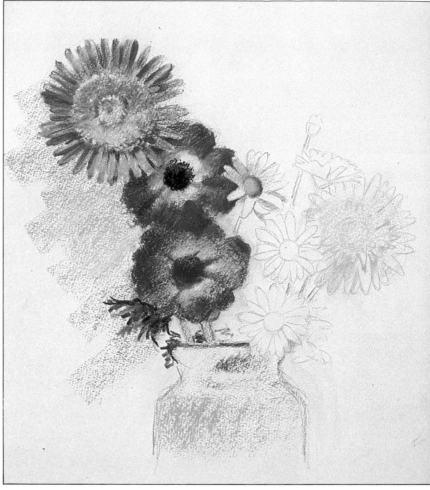

186

The technique of painting with colored pencils could be summed up in the following way: *It is the art of drawing with colors.* In effect, colored pencils paint with lines, stroke by stroke, with few possibilities of composing colors by mixing them. There are sixty to seventy different colors available, allowing you to choose the specific color you need, freeing you from the process of mixing. But you must still deal with all the problems of color: tone, shade, and reflection. With colored pencils, you are drawing and painting, as well as painting and drawing at the same time. It is not unusual in a composition painted entirely with pencils that the lines are used to create boundaries between the forms, or that the contours drawn with lines are used to separate and distinguish them from other forms ... all of this is drawing with colors, or drawing-painting.

In the text and pictures in the following pages, you will read and see the step-by-step development of this painting, in which the importance of drawing as a base in the technique of colored pencils will be confirmed.

187

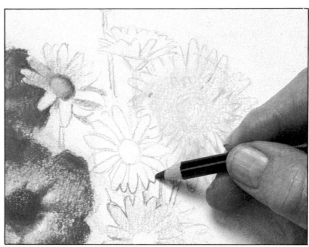

Figs. 187 to 190. The process of painting the fine details of the daisies requires precision and cleanliness. First, I outline the flowers with the colored pencils (fig. 187). Next I apply a light pink to create the shadow (fig. 188), and then I paint a light blue on top of the pink to get, as you can see, a bluish gray that corresponds to the petals of the daisies that lie in the shade (fig. 189). At this point the orange flower, the two red flowers, and the daisies are practically finished. I only have to add some dark green patches to separate the forms of the daisies (fig. 190) and the painting-drawing begins to take shape.

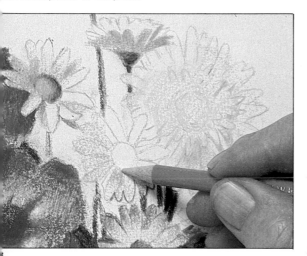

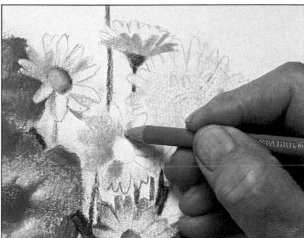

189

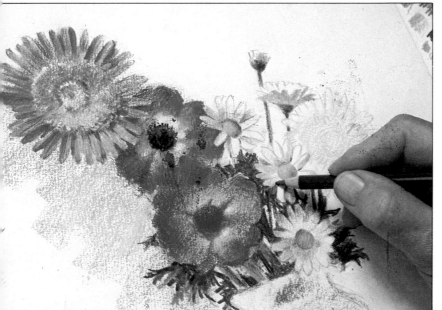

191

Fig. 191. Here, I am using a blade to create a light green stem, by "opening" a white line in this small area of dark green.

The finished picture

Figs. 192 to 199. Now, I am in the final stages of the drawing, which you will see step by step: I start by painting the upper portion of the background gray, with flat strokes, using a piece of all-lead stick (fig. 192). Because it is not possible to paint around the contours of some of the forms (like the petals of the daisies) with the all-lead stick, without "covering the lines," I will use a gray-colored pencil (similar in tone to the all-lead stick) to harmonize these small areas (fig. 193).

Directly afterwards, I apply a "whitening technique," which calls for painting white over a specific color; in this case I am using an all-lead stick. This technique must be done with great intensity and energy (fig. 194).

The next step consists of "whitening" by outlining the forms and contours with a white pencil (fig. 195).

Here, I am defining the upper portion of the vase that appears in the painting (fig. 196).

Then, I decide to simplify and shorten the extension of the background. I do this by rubbing very energetically with an eraser, creating an irregular stumped gray effect (fig. 197). Now, I must touch up this stumping effect with the aid of a gray pencil (fig. 198).

Finally I revise and touch up the small forms and different shades of color. When doing this, remember to work with a paper protector under your hand (fig 199).

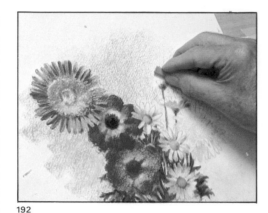

192

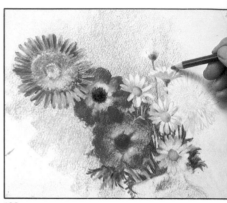

193

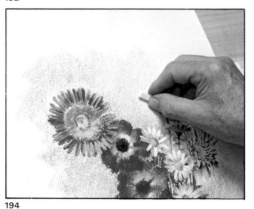

194

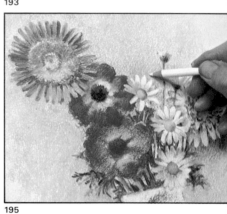

195

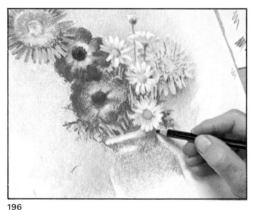

196

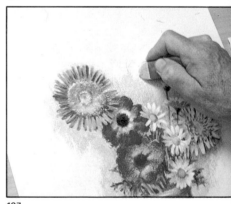

197

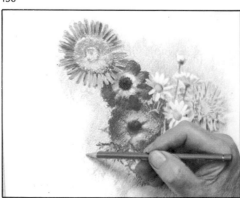

198

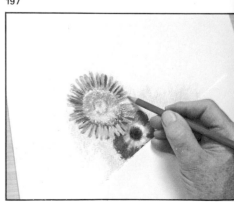

199

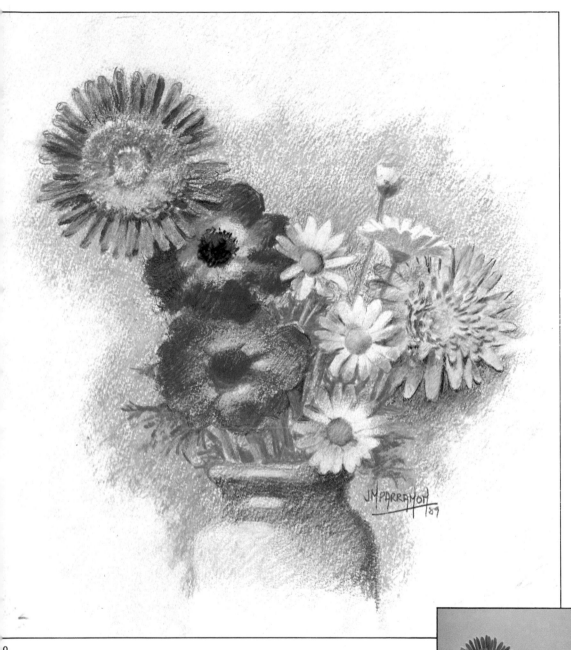

201

0

Figs. 200 and 201. This is what the finished painting looks like (fig. 200). I have used more than thirty different colors without having to mix. Some unique contrasts were created when I darkened the edges of the forms with the background. By adding dark green forms, I gave shape to the flowers. I tried to paint this picture using *unity within variety*. The position of the flowers was varied to eliminate any "holes," or spaces, between each flower, thus creating unification and contrast in the composition. If nothing else, I hope that my experience will encourage you to paint and draw with colored pencils.

Crespo paints anemones with oils

Now Crespo is going to paint with oils some red anemones in a ceramic vase. There is a jug next to the anemones and a plate, or ashtray, that complements the composition of the painting (see the model in figure 202). "I bought these anemones yesterday," explains Crespo; "they were very closed, so this morning I turned on the heater to warm the room in order to open them up. I can't paint the anemones for more than two sessions because they wither."

The materials

As you can see in figures 203 and 204, Crespo's palette is a 23½"×23½" (60×60 cm) wooden board, which is quite a large surface area. It is situated in front of the easel, maintaining a comfortable distance between the artist and the canvas. You can see the following colors on the palette that Crespo is going to use.

Titanium white
Yellow ochre
Yellow medium
Yellow orange medium
Cadmium red
Carmine madder
Permanent green
Sap green
Raw umber
Prussian blue
The following are some special colors that Crespo is going to use:
Cobalt violet light
Scarlet pink
Violet dark
Cadmium red deep
Apart from these industrially manufactured colors, Crespo is using four home-made colors: yellow ochre, neutral gray cool, a gray sienna warm, and a broken blue-grayish.
In figure 204, you can see the brushes and basic materials that Crespo will use: nos. 8 and 12-14 bristle brushes; nos. 6 and 8 cow-hair brushes; 1" and 1½" flat brushes; and spatulas.

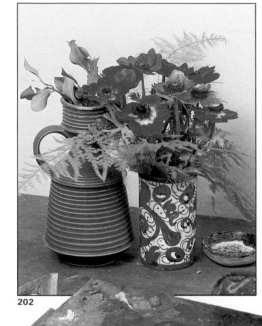

202

Fig. 202. This is th model that Crespo w paint with oils: som anemones, in a decor tive blue ceramic vase, blue-gray jug, and small ashtray.

Figs. 203 and 20 Crespo's palette ha some special colors th he has made himself (fi 203). Here, you can se the round brushe scraper, and spatula that Crespo will use paint this picture (fi 204).

Figs. 205 to 208. these figures you will se how Crespo develop the picture by paintir with blue diluted in tu pentine.

204

First stage: the drawing

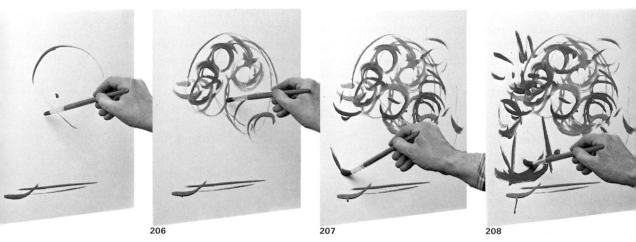

206 207 208

clean the brushes as he paints, ~spo wipes them on the pages of an ~ telephone book. "It is practical, ~ctional, and economical," says ~spo. He then washes the brushes in ~lass of mineral spirits and finally ~ans them with an old rag. "I only ~ turpentine for diluting color," ~spo adds.

~spo starts the painting on a canvas ~rd. He thinks about and then prac- ~s the first stroke in the air, moving ~ hand as if he were actually paint- ~. Then, taking the no. 8 cow-hair ~sh, which is loaded with Prussian ~e and lots of turpentine, he quick- ~sketches in the general proportion, ~ting, and structure of the picture. ~at is so extraordinary about this ~cess is the ease with which Crespo ~ates the drawing—the initial struc- ~ for the painting. With quick and ~e brushstrokes, he draws circles and ~rals with the hand raised. All his ~vements are calculated and fast, ~ost spasmodic. Crespo takes short

breaks to give him time to observe and calculate, and then he resumes draw- ing with rapid movements—a stroke and a leaf, a circle and a flower (this process is illustrated in figures 205 to 208).

The end of this first stage is clearly seen in figure 209.

Fig. 209. This is the finished sketch that de- fines the proportion and dimension of the flowers in relation to the vase and jug.

209

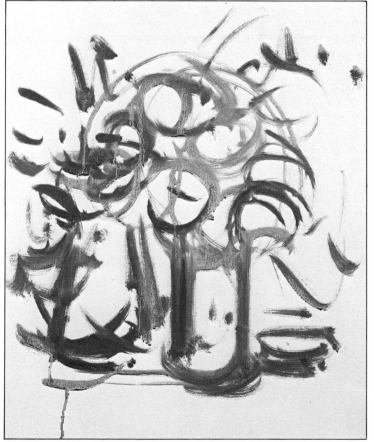

Second stage: the background

Now it is time to paint the background. Crespo decides on a warm gray, which he creates by mixing his home-made neutral gray with white, ochre, and orange. Using a wide brush, he paints the warm gray over the initial strokes that were drawn in Prussian blue. When the two colors mix, a neutral gray is produced.

Then, Crespo mixes burnt sienna with the wram gray and carmine madder to compose a dark sepia. He uses the dark sepia to paint the surface where the vase and jug and flowers stand.

Crespo alternates between a wide brush and a spatula of the same width. Now and again, he adds "strokes" with the edge of the spatula, drawing thin white negative lines, to create *a rough* effect. He looks at the model again and again, and paints more patches, all the while ignoring the details. He seems to be looking at the model with half-closed eyes. Crespo says that when the subject is a distance of 7 feet from the easel, he does not consider it necessary to half-close his eyes, "like when I'm painting a landscape with a very wide angle of vision, and I have to take in the many forms and large masses of color."

Crespo continues working on the background with a flat brush and spatula, defining forms and synthesizing the tones and colors of the background (figs. 211 to 213).

Figs. 210 to 213. Corot once said: "F the background." the background, Cres uses gray, ochre, a orange in the upper p tion, and burnt sier with carmine madde the lower portion. uses a wide 1½" bru and alternates it wit spatula of similar dim sions to paint and scra the edges.

Fig. 214. This third sta shows you that Cresp well into the form a color harmonization the painting.

210
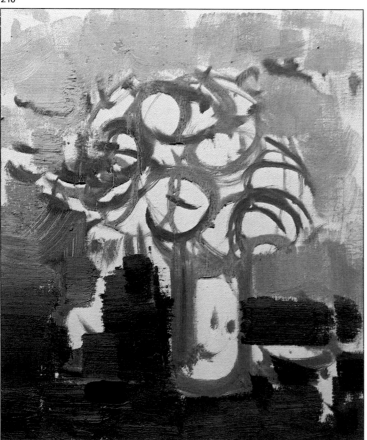

211
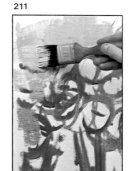

212

213
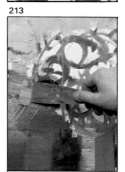

Third stage: painting the anemones red

ith the same spatula he used to paint
e background, Crespo cleans the
lette, leaving no trace of any paint.
To paint flowers,'' Crespo explains,
t's important to work with clean
lors. We must be able to mix colors
a place where the leftovers won't in-
fere.''
1 the clean palette, Crespo squeezes
t the special colors from tubes:
balt violet light, scarlet pink, violet
rk, and cadmium red deep. ''Can
u see?'' asks Crespo, while he blends
s mixtures, adding white and a bright
1ge of reds. ''The cadmium red deep
th the violets, the red light, and the
rmine madder, all together make up
vide range of red to work from and
paint the right colors of the red ane-
ones.''
w Crespo starts to paint the flow-
; with premeditated, but at the same
1e spontaneous, brushstrokes. He

paints feverishly in a calculated way,
all the time constructing: creating floral
forms from brushstrokes; harmonizing
the color; differentiating the tone, in-
tensity, and light—darker on the right
side, in the shade, and lighter on the
left side.
Finishing the third stage, Crespo paints
the corollas of the flowers with dark
spots in the center of each flower. In
a special way, he dips the brush in the
paint, brings the brush to the canvas,
looks at the model, places the brush in
just the right position, and in an almost
syncopated and spasmodic way applies
the color. Then he observes the result
and either leaves it as it is ... or returns
to it with more color (see this process
in figs. 215-218).

Figs. 215 to 218. A
stroke of red with a wide
brush creates a petal; a
touch of dark color with
a flat no. 14 brush
makes a corolla.

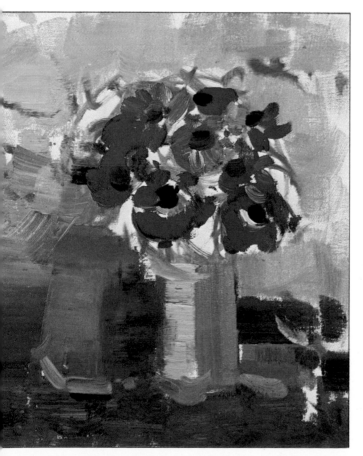

215

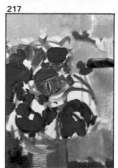

216

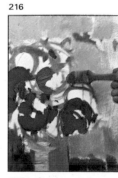

217

218

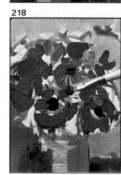

Fourth and final stage: the finished painting

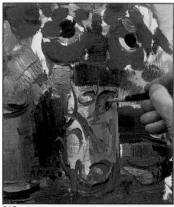

219

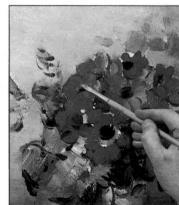

220

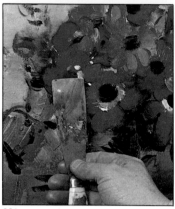

221

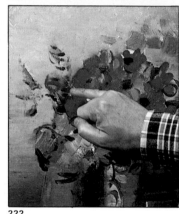

222

Figs. 219 to 221. Crespo begins the fourth stage by interpreting the leaves and stems of the flowers with a range of dark and light greens. He paints step by step without "staying" in any particular area of the picture. He applies blue strokes to the vase (fig. 219); resolves the floral forms and colors with a no. 8 brush (fig. 220) and a spatula (fig. 221); and then he stumps and gradates tones and colors with his finger (fig. 222), and uses the brush again to correct the forms.

Here, Crespo is painting the dark blue design of the vase that contains the anemones (fig. 219). He uses his characteristic spontaneous brushstrokes to do it.

Crespo alternates between his wide brush and the no. 6 round cow-hair brush, along with the wide spatula, blending colors and forms into the flowers and leaves. He "paints" and touches up with his little finger, com-

bining the strokes from the spatula a brush with his fingers (figs. 220-22 The result of this painting process, w rapid brushstrokes and then a "slow motion," is a spontaneous, fresh la guage of calculated improvisation Crespo is now thinking about the co tinuation of the painting in the n and last session. "It is good to lea the painting two or three days to c so that it can be painted on without risk of mixing with the first colors. I of course, the anemones won't be fresh as they are now. It is necessa to be able to paint from memo without the exact reference of model."

Three days have passed since the fi session and Crespo begins the fi stage. He is not painting the model; paints from memory—interpreti drawing, and painting according what he remembers.

For this session, he prefers to use nos. 6 and 8 cow-hair brushes, as w as his little finger to blend, grada and even paint.

Crespo finishes the painting and lesson by saying, "Now, we have work without haste, studying and c culating, separating ourselves from painting and contemplating on it o again. We must respect what was do in the previous sessions, conserving spontaneity and fresh brushstrok that interpret our experience of bunch of flowers."

The final result of Crespo's paint is seen in figure 223.

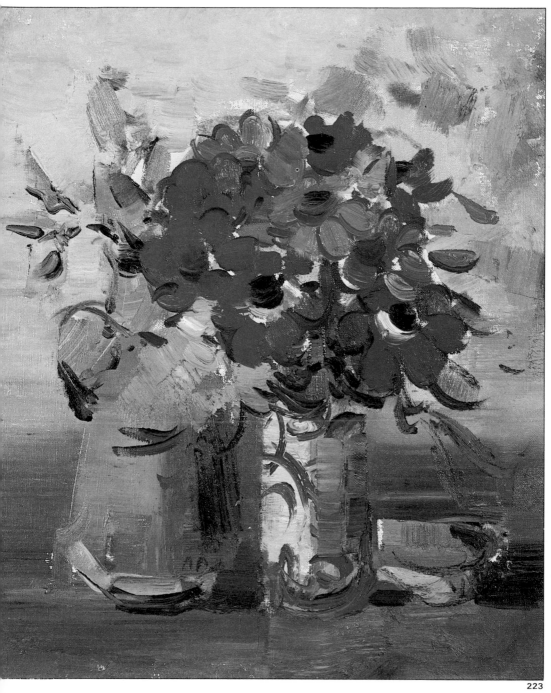

223

Fig. 223. He finishes the painting when the colors are semi-dry, sometimes painting and repainting the color or the form of a leaf or a flower. He de- letes or adds with small touches of a brush. Crespo imagines, cre- ates, and lives intensely through the pleasure of painting flowers.

Parramón paints a picture with watercolors

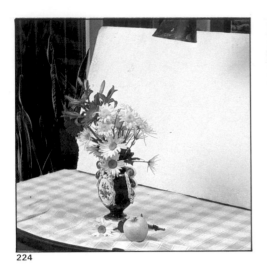

224

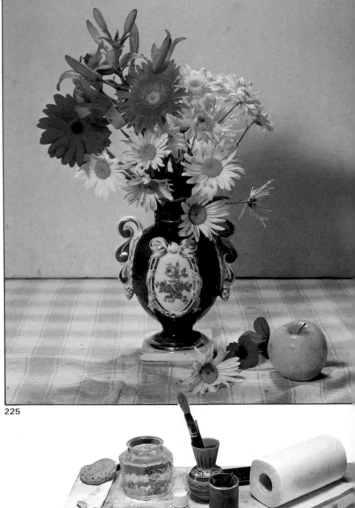

225

Now I am going to paint some flowers in a ceramic vase, next to an apple and some flowers, on top of a checked tablecloth (fig. 224).

As you can see in figure 225, I composed a neutral white background with a polystyrene board.

In figure 226 you can see the paintbrushes I am going to use for this painting: two round sable-hair brushes (nos. 8 and 14) and a wide synthetic brush mixed with sable hair (about 1½″ wide). The wide brush has a handle made of shell, the point of which can be used to scratch and open up white spots.

I have the following tubes of creamy colors on my plastic palette: cadmium yellow light, yellow ochre, viridian, vermilion, carmine madder, ultramarine blue, cobalt blue, Prussian blue, and Payne's gray.

Other materials I will use: water in a glass jar with a wide neck, a small natural sponge, liquid gum, a roll of paper towels, reserve tubes of watercolors, tweezers, pencils, and auxiliary brushes.

I am going to paint on Arches paper, which can be bought in twenty page blocks of 10¼″×14⅛″ (26×36 cm). As you know, this kind of paper does not need to be stretched or mounted, thanks to its thickness and the gummed edges.

226

Figs. 224 and 225. I have placed the model in front of a clear background made of polystyrene (fig. 224), planning a light-colored composition in accordance with watercolor painting. You can see in figure 225 that the model consists of some daisies, lilies, and chrysanthemums in a ceramic vase, placed next to an apple and some flowers on top of a checkered tablecloth.

Fig. 226. Here are materials needed paint with watercolor palette with vari colors, brushes, twe ers, a roll of absorb paper, a natural spor and a water contain

First stage: a sketch

I believe the success of a watercolor painting can be summed up with two basic factors: an accurate picture and a spontaneous painting. By accurate I do not mean meticulous. I think a watercolor should be a well-structured picture, with dimensions and proportions that respond exactly to the model, but without the necessity of including the small details, such as drawing every leaf or petal. The second factor of spontaneous painting allows the artist to paint in a fresh loose way, without making the painting seem too precious.

With these concepts in mind, you can see in the pictures on this page that I have synthesized the red and orange flowers by drawing them as circles with converging lines. The daisies are handled the same way and correspond to the other flowers. Notice how the ceramic jug is carefully drawn, though it is still a sketch. Also take note of the quality of the drawing. I need a linear drawing without shadows because of the transparency of the watercolors (shadows would dirty the transparency of the colors). Therefore, the shadows and forms must be made with color, they must be *drawn with colors,* something you are about to see.

Figs. 227 to 229. First, I need a linear sketch without shadows, with as few lines as possible. Remember that watercolors are transparent, so you do not want to see the pencil lines in the finished painting. In figures 227 and 228 you can see that the red flowers are drawn with a simple circle and some radial lines, and two circles represent the daisies.

227

228
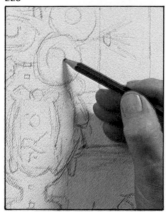

229

Second stage: whites and light colors

Now, I will begin to paint. But first let me remind you that in watercolor painting it is important to reserve the whites and light colors. As you know watercolor is not opaque; it is transparent, and the color white is the white of the paper you paint on. As a result a painter always, or nearly always, "goes around" the white forms to save them. Saving the whites starts at the very beginning of the painting process. Generally, first the background is painted in and then you begin saving the whites of the forms in the foreground and middle ground. I will start this picture in the same way, by painting the background, which represents the sky, with a dark blue. (I paint on an inclined board, with enough mixed color to keep the background uniform and regular without breaks).

There may be situations where the theme calls for a light-colored line, or some thin strokes, to be saved against a dark background; this is the case with flower A in figure 231 (see the finished pictured on page 103, fig. 250). In such cases of saving fine lines, you can use a liquid gum, a preparation that looks like rubber and is applied with a brush, which is later removed by rubbing with an eraser. The liquid gum can dissolve in water, but only up to a certain point—the brush becomes difficult to clean, the gum gets caught in the hairs of the brush, which can even ruin the brush. My advice is to use a liquid resist only when it is extremely necessary, in cases when it is difficult to save by painting around the form. If you use a liquid gum, remember to use an old brush.

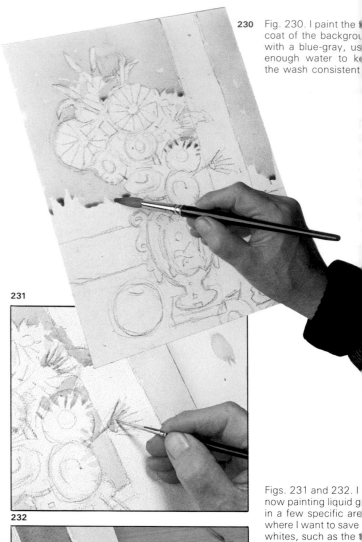

230

Fig. 230. I paint the first coat of the background with a blue-gray, using enough water to keep the wash consistent.

231

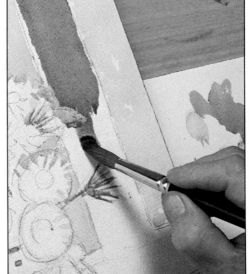

232

Figs. 231 and 232. I am now painting liquid gum in a few specific areas where I want to save the whites, such as the thin lines of the light-colored flower in front of the blue window frame (fig. 231). Notice how waterproof the liquid gum is with respect to the watercolors.

Fig. 233. Liquid gum is also good for saving the shiny reflected areas.

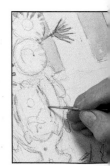

Third stage: finishing the background and applying the first colors

fter having painted the frame of my
maginary window violet blue, I apply
chre yellow, diluted in water, onto the
ky area to try to achieve a light but
arm atmosphere. In order to obtain
 good gradation, I paint the picture
pside down, squeezing down on my
rush as if it were a sponge. I then go
n to paint the red flower, the orange
ower, and the pumpkin-colored lilies.
ext, I give the vase its first coat of
ark blue. Then I apply the initial coat
f yellow ochre for the apple, using
 more dilute mix of color for the
pper left-hand side to represent the
luminated part. Look at the upper
entral part of the apple, those
rayish green stains are the shiny parts,

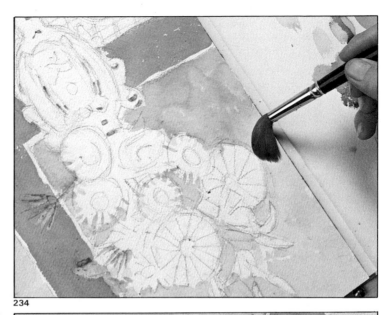

234

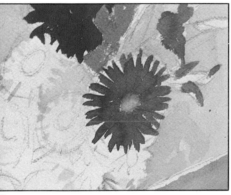

5

hich have been saved with liquid
um.

 will not be long now before the
ainting is complete with all its
olors—not more than ten minutes.
ou can see that it is nearing comple-
on.

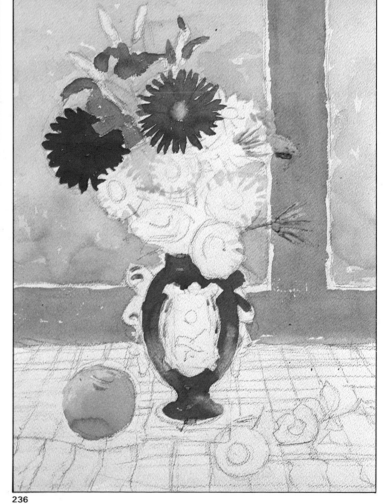

g. 234. Now, I am
inting a second coat of
arm colors onto the
wer portion of the
ackground by turning
e painting upside
wn, which makes it
sier to blend in this
lor with the first coat.

Figs. 235 and 236. In
these pictures you can
see the necessity of
painting and drawing to
resolve and save the
forms of the initial
sketch.

236

Fourth stage: sizing up the color

I begin this stage by erasing the liquid gum from the flower forms against the window frame. Then I focus on the vase: I model its form and work on the medallion area—the decoration in low relief in the center of the blue vase— using a liquid gum to save some shiny spots. Next, I give the yellow flowers a second coat, which leaves them practically finished. Now I must work around the petals of the white daisies, in order to save their white forms. Naturally, you cannot expect absolute precision, to paint every detail of each petal. The most important thing is that you can immediately recognize the subject's forms and colors; in short, to know without any doubt that they are daisies.

There are no rules to explain how to create this type of painting—realistic impressionism. The only way to learn is by painting many flowers.

237

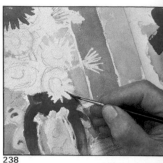

238

239

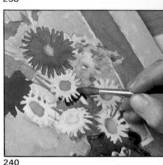

240

Figs. 237 to 240. Here, you can see me erasing the liquid gum, leaving perfect white patches and lines that will allow me to paint light forms onto a dark background (fig. 238). In the next figure notice how useful absorbent paper can be to test colors, graduate tones, and unload your paintbrush. Observe the reserve work on the petals of the daisies, which I painted around.

Fig. 241. Finishing this stage I get a general view of the color, which still needs to be adjusted and contrasted with the forms.

Fig. 242. In this newly painted dark-colored area of the painting, I "open up" the whites by using the handle of the brush to draw in thin lines of flower stems. There are blunt-ended paintbrushes made of shell on the market that are ideal for "opening up" lines.

Figs. 243 and 244. Reserving the profiles, or painting "in negative," graduating washes, and drawing at the same time are the technical essence of watercolor painting.

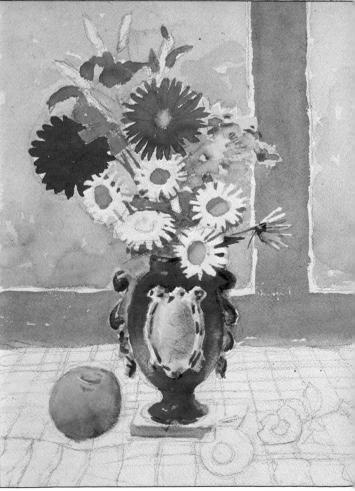

241

Fifth stage: the painting is practically finished

All the forms and colors are now ready except for the details, which are clearly explained in the following pictures. The secret of creating whites—white spots, strokes, or light-colored lines—on a dark background is to paint in the dark color and while the watercolor is still wet, scratch into it with a hard pointed object. You can use a variety of objects: the tip of your fingernail, the end of a brush, or the shell-made handle of a wide brush, which has a blunt point. In figure 243 I am finishing the petals of the daisies, saving the white of the paper. As a result you get the feeling that the daisies were painted with white paint. I also want to bring to your attention that I am paint-

ing with a thick no. 8 brush, instead of a fine brush, which would make it easier to save the little forms in this area. But I believe, as other painters do, that the moment you paint with fine brushes you are no longer participating in the art of watercolor. Fine brushes are used for painting fine details, which goes against the fresh spontaneous style of watercolor painting.

Fig. 245. Only the fine details need to be added to finish the painting.

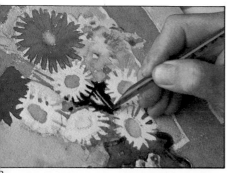

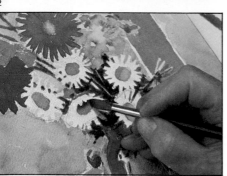

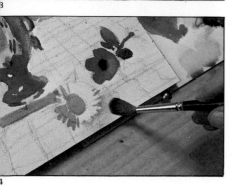

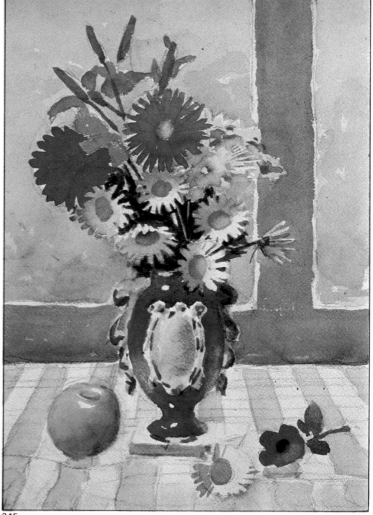

245

Sixth and final stage: the end product

For painting the pattern of the tablecloth, I must wait for the series of horizontal lines to dry in order to paint the series of vertical lines. At the same time, I must keep in mind the perspective of the composition—the convering lines that create depth. In most cases you should wait for one area to dry before you begin the second coat.

Next, the lilies: I first paint the buds and leaves with a green ochre light. After waiting for it to dry, I paint a sap green deep to enhance the shape and the shady areas. Later, I will paint in the shadows and more intense colors of the lilies, after the buds and stems are dry.

I finish the red flowers by painting them with a few blobs of more intense and deeper coloring, responding to the synthesis of form and color of the composition as a whole.

Now I must paint in the green stems and leaves of the flowers on the table, and the shadows produced on the tablecloth by the jar, apple, and loose leaves. After painting in the flowers that decorate the white medallion on the vase, I am finished with the painting.

Figs. 246 to 249. In these figures you can see how the detail work is carried out against the checkered tablecloth: the buds of the lilies, the shadows of the leaves of the small red flower on the tablecloth, and the shadows of the jar and the apple.

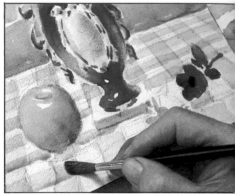

246

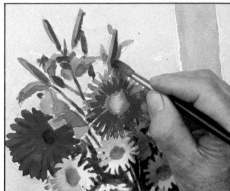

247

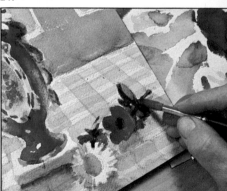

248

249

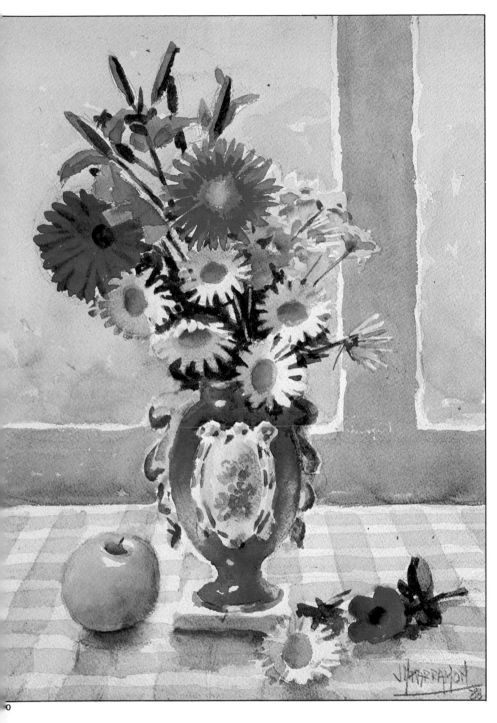

Fig. 250. The finished painting shows you that watercolor is a perfect medium for expressing the delicate and luminous richness of flowers. The painting also tells you that in order to achieve such results, it is necessary to study and practice painting often, to learn everything about *drawing-painting*, and saving the white or light areas.

Crespo paints nasturtiums with oils

251

252

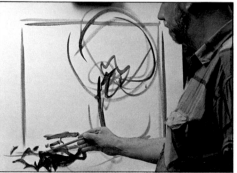

253

Fig. 251. In this last example of the art of painting flowers, Crespo is going to paint with oils a still life composed of nasturtiums in a jug, a ceramic piece, a dish, a glass, and a green bottle.

Figs. 252 to 254. Crespo starts the painting by drawing a rectangle to create a setting for the model. Then he continues to paint a series of forms inside the rectangle that will determine the forms of the still life. At the moment, the painting appears to be abstract.

With the model in front of him Crespo explains, "This type of flower withers very easily, so I will have to paint the picture in about two sessions. First, I will try to capture their freshness, leaving the second session for doing the background, ceramics, and even the leaves, knowing fully well that the flowers must be captured on the first attempt."

He starts the painting. There is a moment of silence and study, looking at the model and then at the canvas, from the canvas back to the model... Now he begins by drawing a rectangle inside the canvas (fig. 252). At this point I ask him, "Are you going to reduce the size of the picture?" Crespo answers "No, this initial rectangle is the setting—*the size and measurement of the model situated within the whole painting*—so I can calculate beforehand the margins around the model."

Drawing with a brush, using raw umber deep and lots of turpentine, Crespo paints the major shapes of the composition.

254

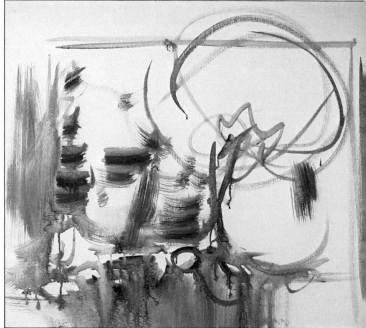

Second stage: drawing and painting the background

or this painting, Crespo uses a wide ⅛″ brush and the colors burnt umber, red, green, ultramarine blue and white for his palette. He applies the white in the area that will be the lightest area of the background. The raw umber deep, used to draw in the shapes, blends with the white to produce a clear gray, which is very close to the model's background. Crespo sketches the form of the bottle with permanent green and white, us-

ing horizontal brushstrokes. Then he takes the spatula to paint in the shadows and forms of the jug and dish. Drawing lines with the edge of the spatula, he produces a wide curve for the jug of flowers. Now, using a round brush, he paints around some white areas, which he will use later for the yellow, orange, and red colors of the flowers.

Figs. 255 to 257. In these three images there is no figuration, only an abstract painting made up of some dark-colored patches that Creso mixes with green and white. While Crespo works on the background, he also reserves space for the flowers.

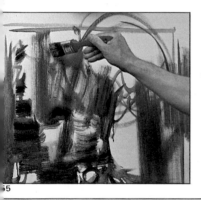

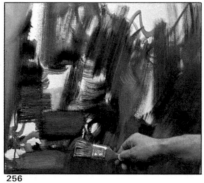

255

256

257

Fig. 258. Here the canvas is totally filled with the colors and forms that will establish the configuration of the still life.

258

Third stage: adjusting the form and color

Figs. 259 to 261. Crespo is now painting in the flowers, using a wide 1¹/₈″ brush and a spatula of the same width. He synthesizes the forms, creating petals with the touch of the spatula or with the stroke of his wide brush (figs. 259 and 260). In this third stage, you can see that the canvas is practically covered with color.

Here, Crespo starts to apply the first colors to the petals of the flowers, using a no. 12 wide brush. The colors he is using for the petals are cadmium red light and cadmium orange yellow, complemented and mixed with cadmium yellow ochre medium. He paints the wide leaves of the flowers with a similar wide brush, though sometimes he uses a spatula, producing wide strokes that form rectangular color patches (figs. 259, 260, and 262). Af-

terwards, with a round cow-hair brush he outlines the forms of the petals and leaves by using a deep gray that is almost black (fig. 263).

As you can see in the last picture of the third stage, Crespo has made some initial adjustments to the forms and colors. He will paint and repaint in this stage as he advances toward the final phase of this painting.

You have been able to follow step by step the techniques and materials that

259

260

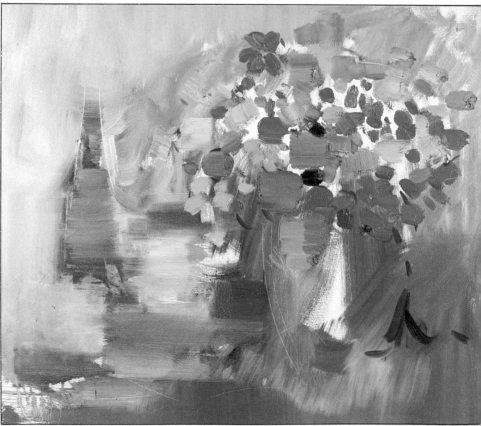

261

respo has employed in his floral aintings. However, you still do not now what the general concept is that fluences his way of painting. Therere, I ask Crespo, ''Can you explain a few words your concept of paintg?'' With a spatula in his hand, he ops work for a moment and answers, I always take care to paint everything the same time. I never go about it ece by piece; from up to down or the ke. The only way is to apply the

colors simultaneously, from start to finish, without ever concentrating on one specific area, so that every part advances in unity, and nothing is definitive until it is finished.''

Figure 264 is a good example of the way Crespo approaches painting flowers.

Figs. 262 to 264. Here, Crespo is touching up with the spatula and painting definitive dark strokes with a round cow-hair brush (figs. 262 and 263). Finally he gets to the stage where the painting appears more complete and advanced in form and color (fig. 264).

2

263

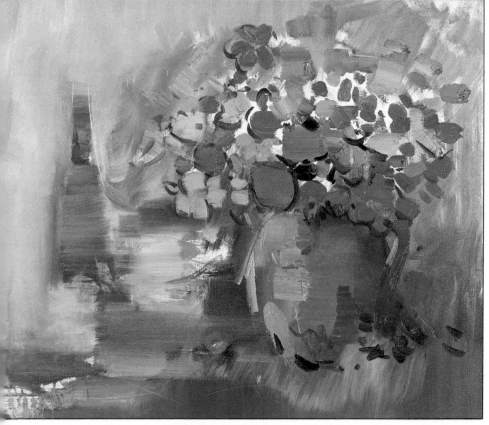

264

Fourth and final stage: the finished painting

265

266

Figs. 265 and 266. After a long process in which he has used all the colors of his palette, Crespo adds sap green to break the luminosity of some of the green leaves. With a brush and spatula, Crespo touches each petal with the brush and each leaf with the spatula. Now the painting is finished.

The painting is nearing completion. Crespo is now working slowly—a brushstroke becomes a petal; a movement of the spatula becomes a leaf. He calculates every touch. With every application of paint to the canvas he studies every shade, tone, and color with great attention. Crespo emphasizes, "You must be able to see the difference in each petal and in each part of the flowers. You need to clearly interpret the colors and contrasts in order to enrich and diversify them."

He prepares a broken luminous green, using sap green as the color base. "You must be ready to invent and differentiate between the colors," he continues explaining as he mixes the sap green with Prussian blue and cadmium orange yellow. "You see? Incorporating the sap green as the beginning of a broken color, I can get a wider range of greens to paint and harmonize the leaves of the flowers."

Finally, there is a superposition of tones and colors that define the forms and planes, which also define the structure of the petals and leaves of the nasturtiums.

The painting is finished, but Crespo says, "I'll leave it till tomorrow or the day after tomorrow. This is always my last piece of advice, because the painting must mature. Two or three days must pass without seeing it, to really accept that it is finished."

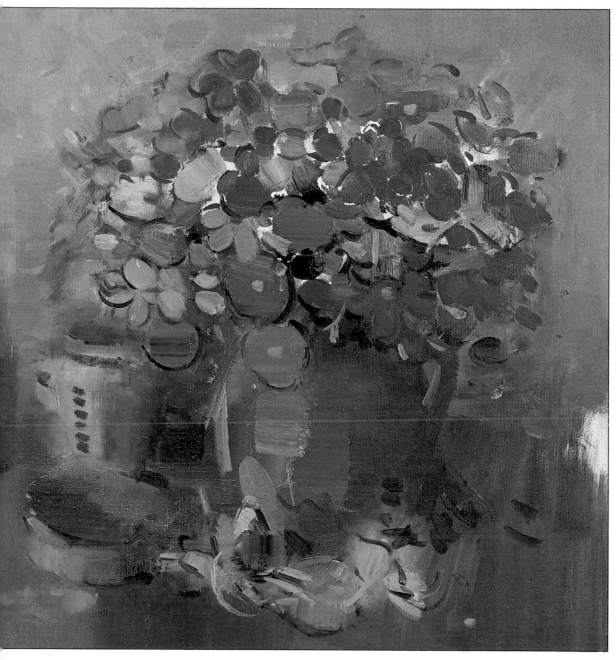

267

Fig. 267. This is the finished product. "It is worth leaving it for a few days," says Crespo. "Then there will be a better color synthesis in the flowers, in accordance with the form and color synthesis of the other elements of the painting." It is important to look back and observe the model (fig. 251). Looking at Crespo's interpretation of the flowers, you can see that they are proportionally larger in relation to the other elements, making the flowers the focal point. The other elements have all been relegated into second position by synthesizing and simplifying their forms and colors. This is a good painting and a good lesson with which to end this book on the art of painting flowers.

An archive

In art there are a number of different kinds of materials and tools that can be used, depending on the techniques you select. Little by little you can accumulate an invaluable collection of art materials that can become extremely personal and irreplaceable.

In the previous pages, we chose materials that are most commonly used by professionals. But now we want to tell you about something that many artists, in all fields, do to make their work easier. We are talking about making a personal archive, a collection of photographs and pictures of flowers that are of interest to you that you can select from.

It really is very easy:
Whenever you go out to the countryside, park, or public gardens, try to photograph the plants and flowers you find interesting. You can also cut out good reproductions from magazines, request pamphlets or catalogs from companies that specialize in plants and flowers, or keep the catalogs from any garden expositions you have visited. Without realizing it you will slowly build up a collection of documental and technical references.

You can arrange it in any way you like: by types of plants and flowers, by their colors, and so forth. All the material can be classified in an archival form, by keeping it in folders.

We are sure that in your future as a floral painter, your archive will serve you well when you are deciding on your next composition.

Fig. 268. Floral painting may be one of the themes that requires the most documentation. It is useful to have an archive, where you can file information by color, class, or form.

268

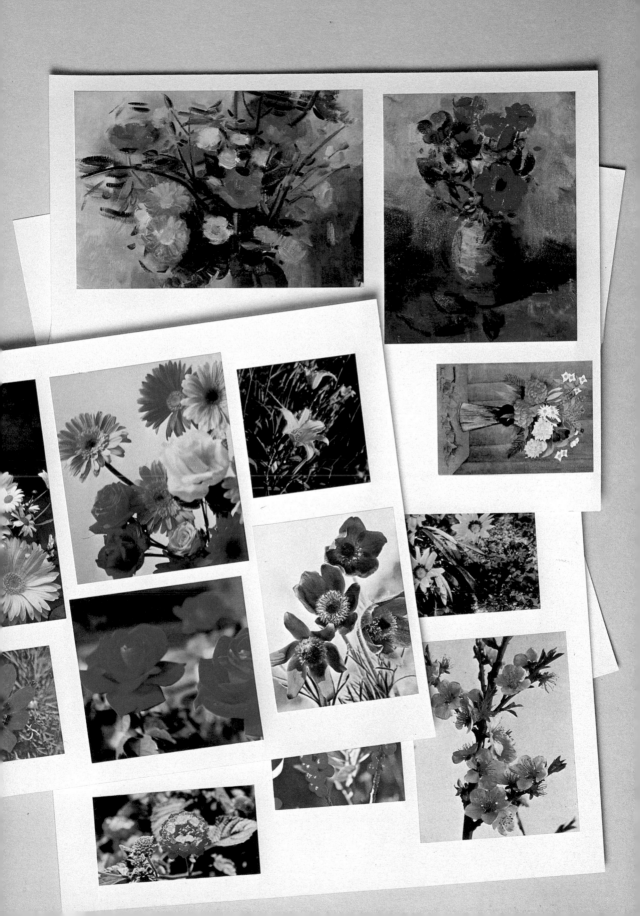